IMAGES
of America

ANAMOSA

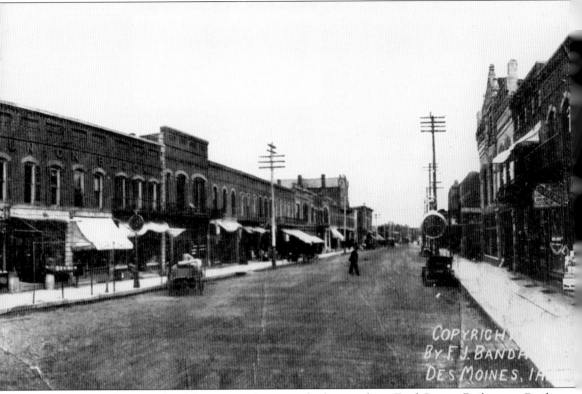

This 1890s photograph of downtown Anamosa looks east from Ford Street. Built post–Civil War in the 1870s, many of these building remain in use today with the exception of the Shaw Block, which is above and to the right of the man walking in the center of the street. (Courtesy of Cecilia Hatcher.)

ON THE COVER: A gathering of men at the Anamosa Lumber Company was not an uncommon site. John and George Watters established the lumber company in 1891. The Watters brothers were connected with many of the business and progressive enterprises of the city. They were known to be absolutely honest, generous, and sociable. Much good humor was carried on around the pot-bellied stove, which was circled by 10 chairs. Now called Anamosa Building Supply, the site remains a lumberyard today.

IMAGES
of America

ANAMOSA

to Jim, Ellen, and Aaron
Merry Christmas ! 2016
from Julie & Maurice

Becky DirksHaugsted

ARCADIA
PUBLISHING

Published by Arcadia Publishing
Charleston, South Carolina

Printed in the United States of America

Library of Congress Control Number: 2012954452

For all general information, please contact Arcadia Publishing:
Telephone 843-853-2070
Fax 843-853-0044
E-mail sales@arcadiapublishing.com
For customer service and orders:
Toll-Free 1-888-313-2665

Visit us on the Internet at www.arcadiapublishing.com

*To those Anamosans who paved the way in the past, work hard in the
present, and seek to improve the future*

CONTENTS

ACKNOWLEDGMENTS

This book would not have been possible without the guidance of Cecilia Hatcher, an Anamosa native with an abundance of knowledge about Anamosa history. She generously shared many of the images within the pages of this book. Unless otherwise noted, all images appear courtesy of Cecilia Hatcher. I greatly appreciate the tolerance of my employers, Jim and Bridget Johnson, and my coworkers as information and images were brought in to the *Journal-Eureka* to be shared. The Anamosa Library and Learning Center provided a copy of the 1988 *Anamosa . . . A Reminiscence* to pour over. The 1879 *History of Jones County, Iowa* by Western Historical Company of Chicago was an invaluable resource, as was the IAGenWeb Project Jones County Pages, coordinated by Richard Harrison. Other photographs were provided by Wayne Hall and his priceless Harriet Cunningham album from 1897–1898. Two other sources were *Souvenir Album of Anamosa, Iowa—Summer of 1891*, published by C.E. Littlefield and F.A. Roehl, and *Picturesque Anamosa*, compiled and published by W. Leon Hall of Cedar Rapids, Iowa, around 1900.

And to my wonderful husband, Dave, who came to Anamosa for me and tolerates being "Becky's Husband" so well.

INTRODUCTION

Anamosa is a picturesque community situated in the heart of scenic Jones County, Iowa. The town of Anamosa was founded as the settlement of Buffalo Forks in 1838. Although platted as Dartmouth in 1840 by Col. Thomas Cox, it was never officially recorded. This did not prevent the name from showing up on early maps of the area. In December 1846, the defunct Dartmouth was re-platted as Lexington by R.J. Cleaveland.

It was with this name that the little town received its first post office in 1847. However, in 1842, a Native American family was passing through town and visited the Ford Inn. Their little girl, named Anamosa, endeared herself to those who met her. Following the family's departure from town, Edmund Booth suggested the town's name be changed to Anamosa instead of Lexington to avoid problems with the mail. So in 1851, the name was changed to Anamosa. In 1853, William Haddock started a newspaper, the *Anamosa News and Journal*, published every Saturday.

The town of Lexington (Anamosa) was selected as the county seat in the spring of 1847 after much political posturing. County business was conducted in private homes until a courthouse was constructed in 1848. It was a simple two-story frame structure, costing $800 to complete. This building was used until 1864, when all the county records were moved uptown to a new brick building owned by H.C. Metcalf. In 1935, the county approved the construction of a real courthouse. This building was dedicated in 1938 and still serves Jones County.

In 1856, most of Anamosa's businesses and houses were located west of Elm Street, with the exception of a blacksmith shop and a wagon shop on the west corner of North Ford and Main Streets. The movement of a large segment of Anamosa's businesses to the east was due to three factors: the wet, marshy conditions in the lower part of town and constant flooding; the building of the Fisher House on the corner of North Garnavillo and Main Streets; and the building of the Dubuque and Southwestern depot at the extreme southeast corner of town.

In 1857, the townspeople spent nearly $100,000 constructing businesses and homes, including $16,000 in the east section called Strawberry Hill. The Strawberry Hill citizens withdrew from Anamosa in 1873 and did not rejoin the city until 1901.

At the west end of town was the "Dublin" section. Dublin was never a village unto itself but was how the locals referred to the original east settlement of Anamosa due to the high Irish population.

Schools were now starting to be built for the classes that had initially been held in homes. Anamosa rented rooms from the United Brethren Church to hold classes in. In 1858, a brick schoolhouse was built by the Strawberry Hill residents on First Street where the Wapsianna Park is currently located. The Hazel Knoll school was one mile north of town. A one-room wood frame school on East Hickory Street also held classes for Anamosa students.

In 1859, Anamosa residents petitioned the village council to establish an independent school district. Seventy voters gave unanimous approval. The new district included the communities of Anamosa, Strawberry Hill, Stone City, and rural Fairview Township north of the Wapsipinicon River, plus a small area south of the river.

The location of the Anamosa State Penitentiary in Anamosa was the culmination of two years of wooing and groundwork by Anamosa citizens. The *Anamosa Eureka* reported that the bill was brought before the legislature by Jones County senator John McKean and was passed on April 12, 1872. Dr. N.G. Sales donated 61 acres of land across Buffalo Creek, and a total of 70 acres was donated by Anamosa citizens for the site of the penitentiary. Dr. Sales won the state contract to supply limestone from his local 80-acre quarry, and work began in August 1872. Built in the style of a castle, the building earned the nickname "The White Palace of the West." The penitentiary, a medium/maximum security prison, is the largest in Iowa, housing more than 1,200 male inmates. The Penitentiary Museum, located on the north side of the prison, contains artifacts and exhibits relating to prison life throughout its history.

The landscape surrounding Anamosa is rich with rolling green hills, farms, and scenic views along the Wapsipinicon River. The "Wapsi," as it is known to locals, flows along the south edge of Anamosa and is home to Wapsipinicon State Park, one of Iowa's oldest parks, dedicated in 1921. The river is crossed by the Hale Bridge, whose three spans were flown here by Iowa National Guard helicopters in 2005 from their original location on the Wapsipinicon 25 miles south of Anamosa, near the village of Hale.

The area's natural beauty has been immortalized by the work of one of Anamosa's favorite sons, Grant Wood. Born on a farm just east of Anamosa, the artist's most famous painting is of a rural couple, she looking stern and he holding a pitchfork. Titled *American Gothic*, it is one of the world's most recognizable and caricatured works of art. Grant Wood died of liver cancer on February 12, 1942. He lies at rest in Anamosa's Riverside Cemetery, just east of a large recumbent lion that bears the Wood name.

Motorcycles are a common site in Anamosa, home to J&P Cycles, which boasts of being the largest aftermarket motorcycle parts and accessories retailer in the world. In addition to J&P Cycles, Anamosa is also home to the National Motorcycle Museum, which features more than 300 vintage motorcycles, including the original "Captain America" bike from the movie *Easy Rider*.

Because of the annual Anamosa Pumpkinfest & Ryan Norlin Giant Pumpkin Weigh-Off held every year since 1989, Anamosa was named the Pumpkin Capital of Iowa by the state legislature in 1993. Held the first Saturday of October, Pumpkinfest brings growers from all over the Midwest, competing for the coveted title of "World's Largest Pumpkin."

Immortalized in the film *Small Town, USA* by the US Information Service and Eurovision in 1957, Anamosa retains its small-town quality. Proud of its 175-year history, sitting at the junction of the Buffalo Creek and the Wapsipinicon River, Anamosa's generous spirit and hometown hospitality are reflected in the stories and photographs within the pages of this book.

One

UPTOWN, DOWNTOWN, OR DUBLIN

Anamosa is actually made up of the villages of Buffalo Forks, Dartmouth, Lexington, and Strawberry Hill. Settling at the junction of the Wapsipinicon River and Buffalo Creek, the first settlers at the "Buffalo Forks of the Waubisipinicon" were George Russ and Sherebiah Dakin, who came in May 1838. In August, sickness claimed Russ and before October, he was dead.

George H. Russ came a few days after his father's death and Gideon H. Ford arrived about the same time. Ford bought him out, and in the winter of 1838–1839 sold two-thirds of the claim to Timothy Davis and George H. Walworth. The claim included the whole site of Anamosa.

Walworth's brothers and sisters moved to the Forks in 1839, and Edwin Booth arrived in August of the same year. Col. David Wood and Booth built the first frame house in 1840.

When Thomas Cox of Bellvue came here to survey the county seat of Edinburgh, he accompanied Walworth to Buffalo Forks and platted off a new town called Dartmouth. However, Dartmouth was never officially recorded and so was dropped.

Two years later, John Crockwell and Harry Mahan laid off a plat just west of Dartmouth and named it Lexington. The name was changed to Anamosa in 1851. It was incorporated as a city in 1872 with Robert Dott being the first mayor.

The origin of Strawberry Hill is elusive, but from 1870 to 1879 it was listed as having 130 occupants with the value of the town lots being $15,110. Strawberry Hill did its best to exist separately until it was incorporated into the Anamosa School District in 1901.

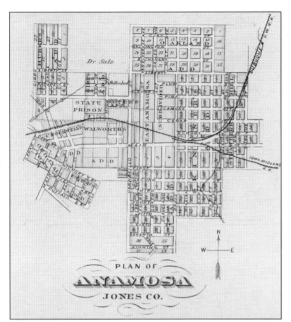

This 1875 Plan of Anamosa shows the original plat of the town in the lower left corner. It was published in A.T. Andreas's *Illustrated Historical Atlas of Iowa* in 1875. Many of the streets remain in the positions shown here.

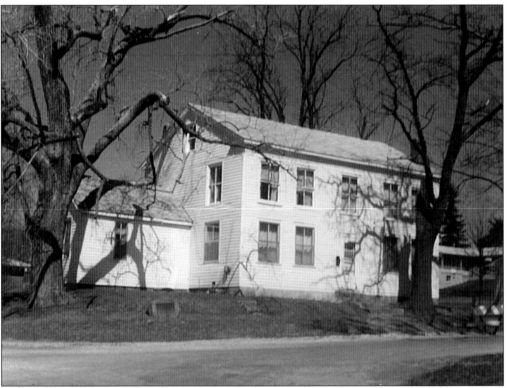

One of the few buildings left in the original site of Anamosa is the Ford Inn at 908 West Main Street, where the young Indian maiden named Anamosa visited. In the lower left corner is a stone boulder holding a bronze plaque that reads: "Site of the Gideon Ford Home, visited in 1842 by Indian Maiden Anamosa for whom the town was named. This tablet was placed by Francis Shaw Chapter D.A.R. 1929." (Courtesy of Becky DirksHaugsted.)

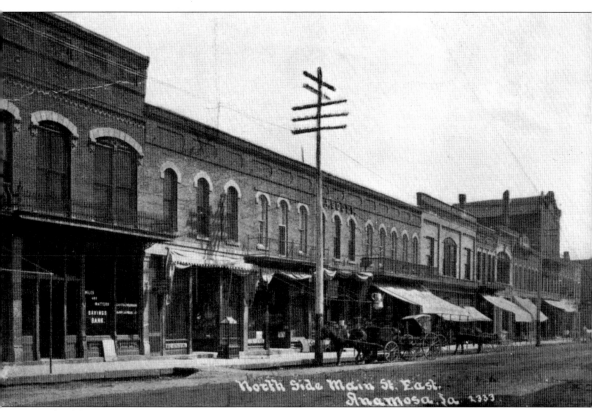

This block of buildings was constructed after the "Big Fire of Anamosa" destroyed the previous wooden structures. Early in the morning of February 14, 1875, wild cries of "Fire!" broke out in the stillness of the night and the Congregational Church bell echoed the dreadful alarm. In a few minutes, hundreds of citizens were rushing in the direction of the lurid light and roaring flames pouring out of what was formerly known as "the old court house building." The headway that the fire had made, along with the combustible nature of the wooden buildings filling the space between the Union Block on the corner of Main and Ford Streets on the west, and Frank Fisher's Block at the foot of Booth Street to the east, made it almost impossible to fight the flames. A total of eight buildings burned to the ground. The total loss was $12,000. The origin of the fire was unknown.

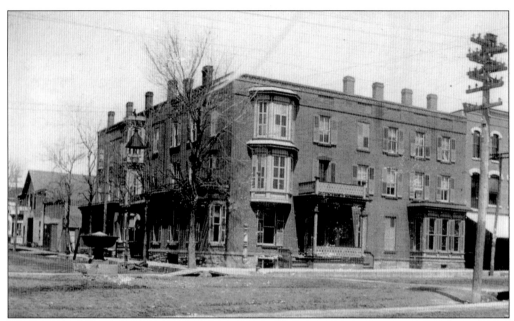

The hotel built on the northeast corner of Main and Garnavillo Streets was one of the catalysts of Anamosa's migration east. Financial backing was provided by Joseph and Israel Fisher, H.C. Metcalf, and N.G Sales. Opened in the fall of 1857, the Fisher House was considered to be too far away from the business center to be a success. Billed as the best hotel in the state, the three-story building could accommodate 150 people. The livery behind the hotel was able to hold 60 horses. The cost of construction was $25,000. In October of that year, Stephen A. Douglas stopped in Anamosa, campaigning for Abraham Lincoln, and spoke to a crowd of 500 in front of the hotel. He continued his travels after a night at the Fisher House. The hotel was sold in 1875 to O.E. Gillen for $7,000. The name eventually changed to the Gillen Hotel.

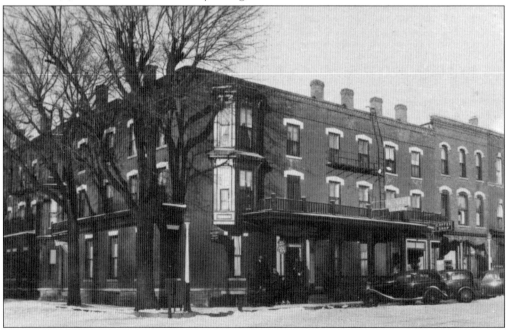

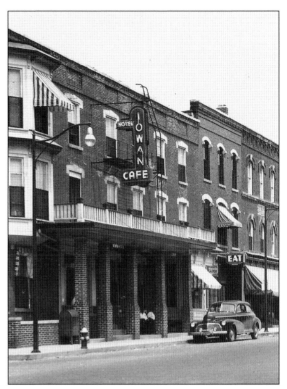

Jesse Holden took possession of the hotel in 1925. Holden and his wife, Alma, owned and operated it until 1945. It did not change its name until 1940, when it became, predictably, the Holden Hotel. Jesse Holden revamped the hotel and it was said to have the most inviting dining room anywhere. The hotel at that time had 35 rooms and six apartments. Bruce Wright later became the owner and changed the name to the Iowan Hotel. It then changed hands many times and fell into a state of disrepair. It was razed in 2003 as part of a downtown improvement project called Streetscapes.

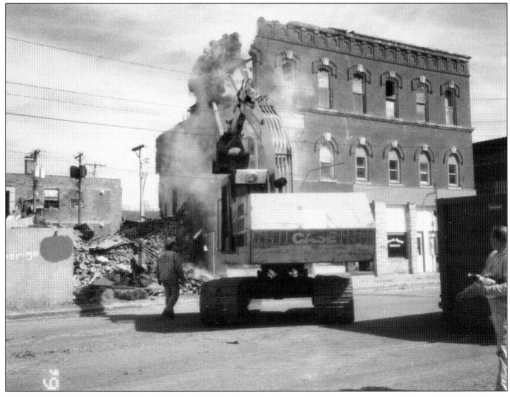

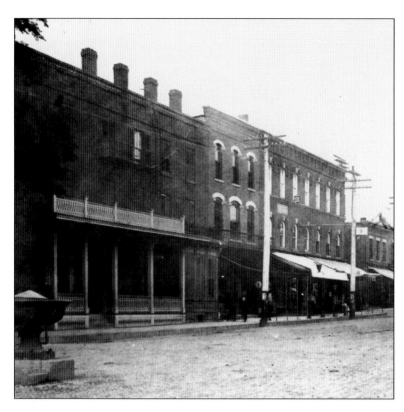

The big news in 1860 was the completion of a three-story brick building by William T. Shaw and Horace Metcalf two doors east of the Fisher House. It contained the post office, a dry goods store, a justice of the peace office, five lawyers' offices, and a public hall used as the county courtrooms. The third floor belonged to the Independent Order of Odd Fellows. A time capsule was found behind the Odd Fellows stone when the building was razed in 2003.

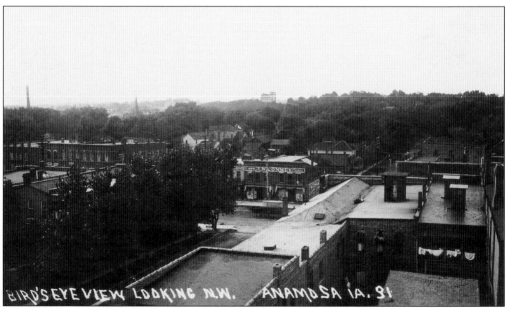

A two-story structure known as the Conmey building was finished in 1865 on the northwest corner of Ford and Main Streets. At the same time, the buildings from Ford Street west to the Fisher House were completed on the same side of Main Street.

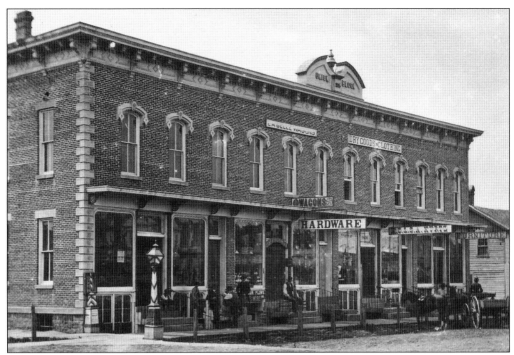

The Union Block on the northeast corner of Ford and Main Streets was completed in 1866. The first floor was divided into three parts. The building was owned by Alderman and Williams. The corners were blocks of limestone from local quarries. In 1925, the building was given a new brick front and the Union Block sign was removed in the process.

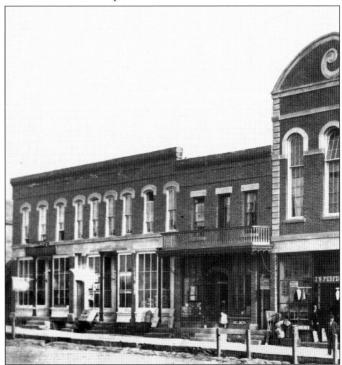

Across the street from the Fisher House and the Odd Fellows building were three brick stores constructed in 1866.

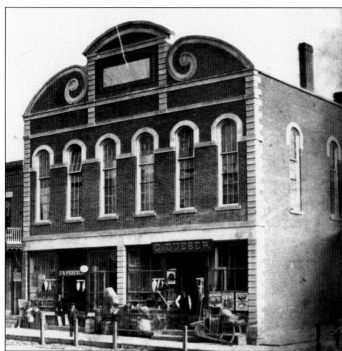

A large structure was completed on the southeast corner of Garnavillo and Main Streets in 1867. It was called Lehmkuhl's Block, and Lehmkuhl was said to have everything from a needle to a threshing machine. It changed hands to E.C. Holt and was called the Holt building. The hall upstairs was home to the city offices for a time and then became the place for all of the town's entertainment, earning the name Opera House.

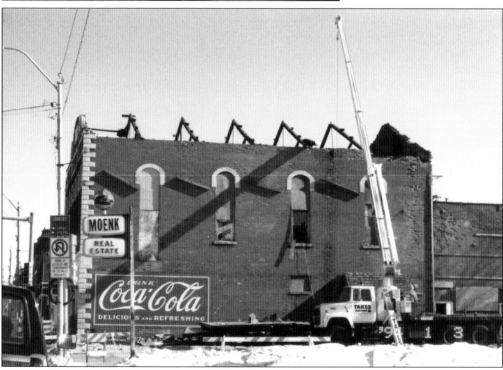

Another landmark was taken down when the top stories of the Opera House became unsafe and were taken off in 1994. The building's transformation was complete when the remaining first floor was resided, causing the city officials to put in place ordinances banning such drastic alterations to downtown buildings.

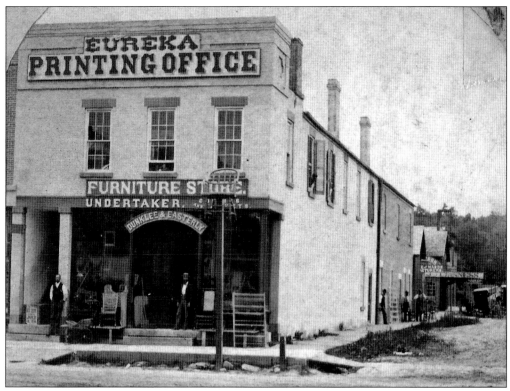

In 1867, the building on the corner of South Ford and Main Streets was finished. The bottom originally contained a store owned by H.L. Palmer and the top floor was built by Edmund Booth to house the *Anamosa Eureka* offices. The newspaper's large treadle press, weighing 5,600 pounds, was moved with the help of a dozen men and a good team of horses.

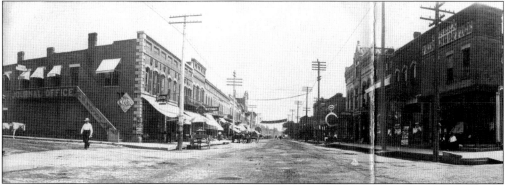

It was no surprise that the *Journal* and *Eureka* newspapers were on opposite sides of the street. However, the staff of the two papers might be surprised to learn that both are still in existence over 100 years later, having been joined together in February 1952 as the *Anamosa Journal-Eureka*.

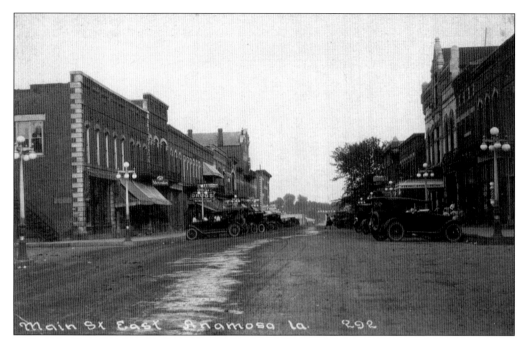

Pictured above is Main Street looking east from Ford Street in the 1920s. The number of cars lining the street is a good indication of how prosperous the citizens were. In the background is the landmark Anamosa sign that was taken down in 1940. Pictured below is Main Street looking west from Huber Street 50 years later. Downtown was the place to shop and visit. No matter that the type of transportation has changed so much, Main Street in Anamosa has maintained its small-town looks, with many of the buildings constructed from 1860 to 1880 still in use today.

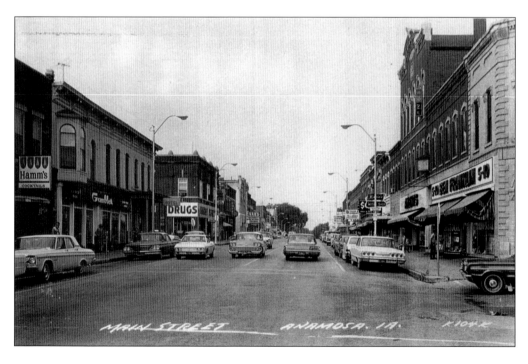

Two

WHERE THE WAPSI
MEETS THE BUFFALO

The 1879 *History of Jones County, Iowa* begins: "The site of Anamosa is quite romantic and beautiful, the scenery in the vicinity adding much to the attractiveness of the city, which sits upon a delightful portion of the undulating timber-land situated at the junction of the Buffalo Creek with the Wapsipinicon River."

Anamosa's history cannot be told without some reference to the Wapsipinicon River, which lies south of town, and its contributory, Buffalo Creek. First situated on the fork of these two streams, Anamosa has since grown to the east, away from the annual threat of flood. However, that has not stopped the town, its people, and the river from being intricately interwoven.

The Wapsipinicon River winds its way for over 200 miles through eastern Iowa before joining the Mississippi. Lovingly referred to as the "Wapsi" by locals, the origin of the name Wapsipinicon is steeped in legend and romance, with a tale of star-crossed lovers leaping from the limestone cliffs, sealing the fate of their love. The romantic stories of Wapsi and Pinicon make for interesting folklore, but the literal translation of the beautiful name is "White Potato River" or "Swan Apple River," referring to the white artichokes that grew along its banks.

So beloved was the area that preservation was started in 1921. The initial parcels that form Wapsipinicon State Park were acquired by the state of Iowa in 1921 and 1922, with additional parcels added as recently as 2009. Wapsipinicon State Park encompasses almost 400 acres of land and is one of the oldest in the state. People camp, fish, boat, and take leisurely strolls in this treasured area.

As one of the most beautiful rivers in Iowa, with so many of its natural features retained, the Wapsipinicon has been designated a Protected Waters Area by the state. The Wapsipinicon River has proven itself worthy of protection and preservation for future generations.

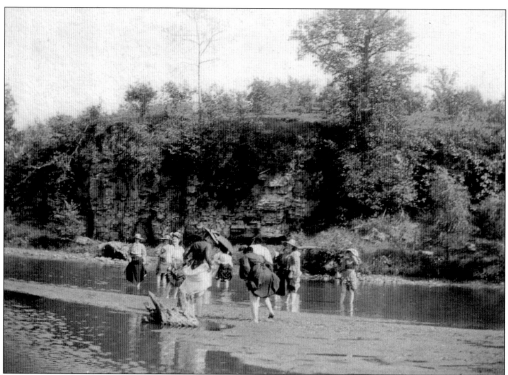

The banks of the Wapsipinicon have always been the place to play, as these ladies of leisure did on what was perhaps a Sunday afternoon. The gentleman below appears to have brought his family fishing on the north bank of the river, dressed in their Sunday best. After the land became a state park in 1922, these Sunday afternoon activities sparked some ire. A letter to the newspaper stated, "On that day only religious services should be observed and the practice of bathing and other frivolities could well be postponed." An editorial defended the activity by pointing out that Sunday was the only time farmers and working people would get any benefit from the park and that there should be no interference with lawful amusement. (Both, courtesy of Wayne Hall.)

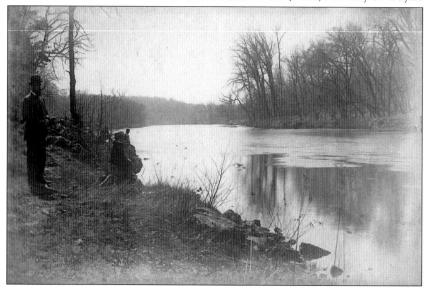

These two ladies and their escorts, taking a break from their scenic boat ride on the Wapsi, have parked just below the Military Road Bridge. Notice the paddle wheel to the rear of the boat, which was probably driven by a steam engine. Boating is still a favorite pastime of those who live nearby.

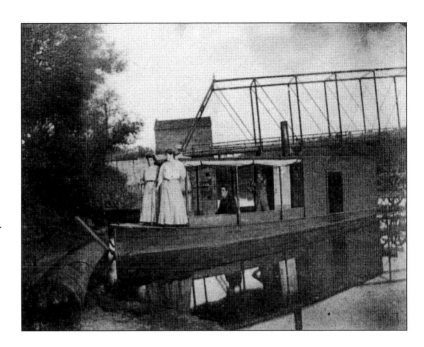

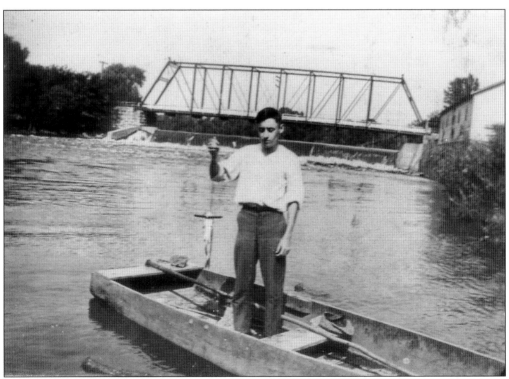

A young Glen McLaughlin does not seem happy about his catch after spending the day fishing on the Wapsipinicon River in the 1920s. McLaughlin went on to become a lawyer, opening his office in Anamosa in 1924 and practicing here until his retirement on January 1, 1984.

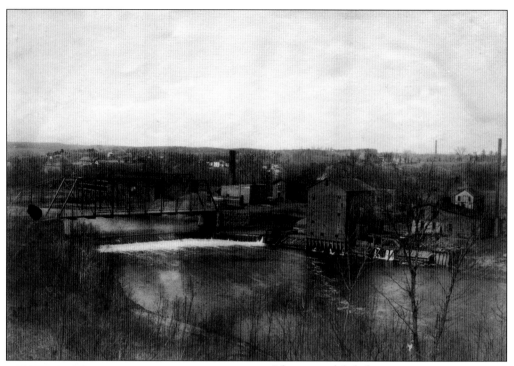

After several failed attempts at getting a bridge to stay across the Wapsi, on November 24, 1887, the *Eureka* proclaimed, "The last plank on the Wapsi River bridge at Doan's Mill, was laid Friday night." Completed by the Milwaukee Bridge Company, the cost of the bridge was $3,000. The abutments were constructed by James Milne at a cost of $5,060. The bridge still stands today and is used as a pedestrian walkway.

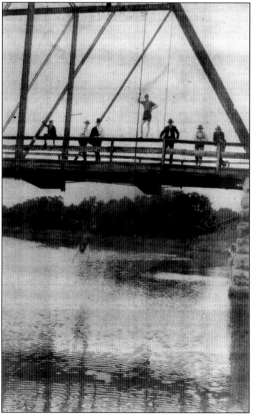

During the summer of 1900, it was discovered that boys were congregating at the iron bridge for the purpose of diving, annoying those who were attempting to cross the bridge. The boy on the railing in the middle of the bridge appears to be gathering his courage for his attempt, while the outstretched arms of one about to hit the surface of the water can be seen in the center.

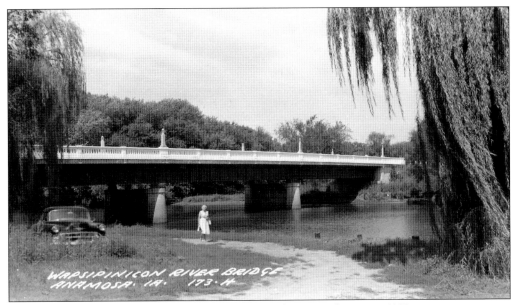

Work on a new bridge 200 yards above the old metal one was begun in 1929 in conjunction with the US Highway 161 project. The bridge was erected first, then the highway leading south from Elm Street was connected to it. This bridge was to remain in place a scant 65 years before it was replaced with yet another bridge over the Wapsi in 1994.

During the late 1850s, horse thieves used inner Dutch Creek Valley to hide stolen horses while camping out in the nearby spacious cave known as Horse Thief Cave. In March 1922, following the blasting of a boulder at the entrance, nine human skeletons were discovered. A.D. "Gus" Corcoran of Anamosa, a student of anthropology, was called in. In addition to the skeletons, he found bone awls, pieces of pottery, arrowheads, and a large mastodon tusk, much of which was carried off by vandals and artifact seekers.

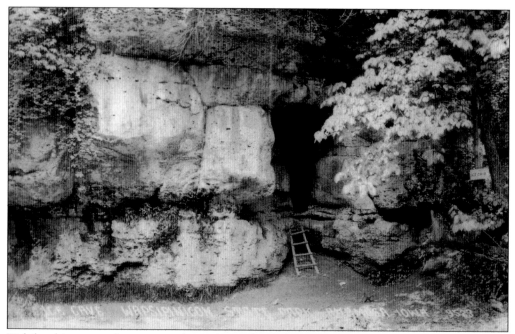

Did the thieves use the cave just down the trail? Likely not, as the temperature inside stays cool enough that it earned the name Ice Cave, as noted in this 1940 postcard on a very small sign to the right.

In February 1921, a meeting was held to gauge interest in purchasing 180 acres and donating the land to the state, which was considering a nearby site. A citizens' committee spearheaded a drive that quickly raised $24,000 worth of pledges in a few weeks. A deed to the site, which originally included 183.49 acres owned by Asa W. Smith and that cost $22,936, was presented to the State of Iowa in April.

When the time came to make the area into an official state park, the school superintendent asked to be informed when the bluffs were to be dynamited to clear the road. Upon receiving the call, the school bell was sounded and the students and townspeople observed the beginning of a road project that would take nearly five years to complete.

In May 1921, an additional 14 acres were purchased from Asa Smith and added to the park. This land was designated for use as a golf course, with an acre set aside for a country club.

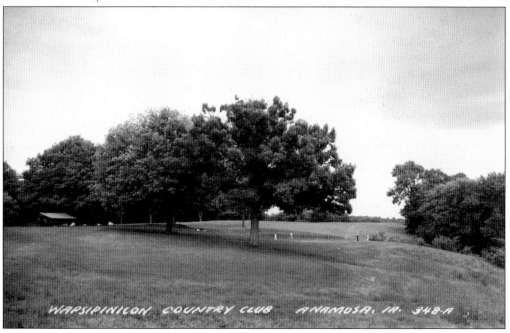

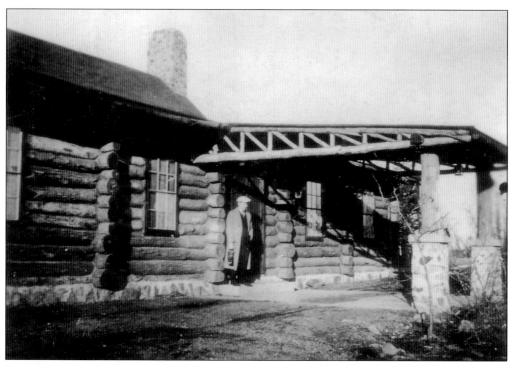

The clubhouse, built with prison labor, was a three-year project. Rock for the foundation was taken from the bluffs overlooking the river, and white oak logs were hauled by horse-drawn bobsleds during the winter from the timber on Buffalo Creek. The club was officially dedicated in June 1924.

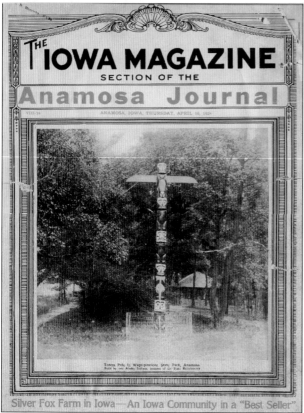

THE IOWA MAGAZINE

SECTION OF THE

Anamosa Journal

ANAMOSA, IOWA, THURSDAY, APRIL 10, 1924

Totem Pole in Wapsipinicon State Park, Anamosa
Built by two Alaska Indians, inmates of the State Reformatory

Silver Fox Farm in Iowa—An Iowa Community in a "Best Seller"

In the summer of 1923, a totem pole took up residence in the first lower flat of the park. It was carved by two Alaskan prisoners and was identical to the totem poles used for worship in Alaska. The totem pole has since disappeared from the park, and its fate is unknown. (Courtesy of Becky DirksHaugsted.)

In 1924, approximately 100 limestone steps were put into place ascending from the lower road up between two bluffs as a shortcut to the country club. These limestone blocks were formerly used as curbing for Anamosa streets. The steps are still in place and used regularly by park visitors. (Courtesy of Becky DirksHaugsted.)

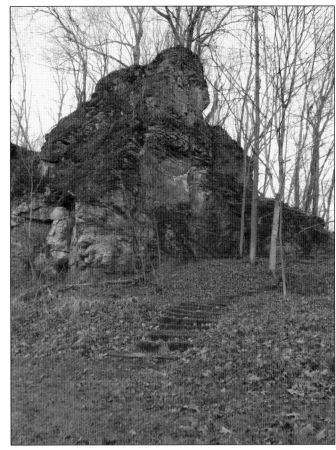

The history of Wapsipinicon State Park did have a dark moment when the Klu Klux Klan held a gathering at the pavilions in Wapsipinicon State Park in June 1924. The uprising caused a state law to be enacted prohibiting masked or otherwise disguised people to prowl, travel, ride, or walk anywhere on state land to disturb the peace or intimidate any person.

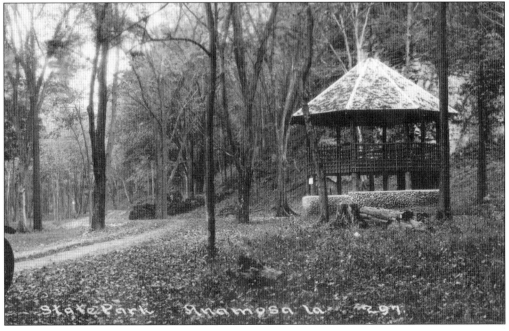

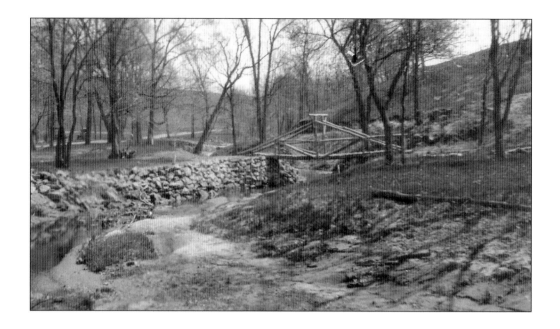

Fortunately, the dark moments of the park are few. In its first year of existence, more than 100,000 visitors made their way to the newly created park. For a time, it was proposed that a zoo should be located there. In spite of collecting a crocodile from Florida, a wolf from Dubuque, and an assortment of reptiles, a full-blown zoo never materialized.

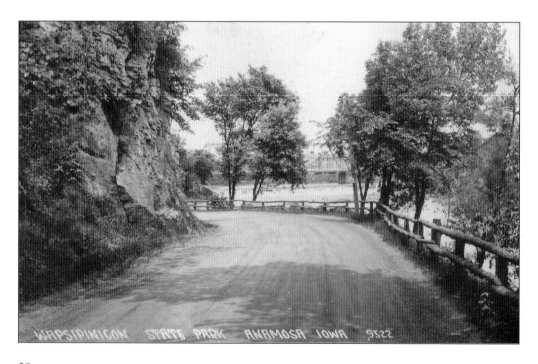

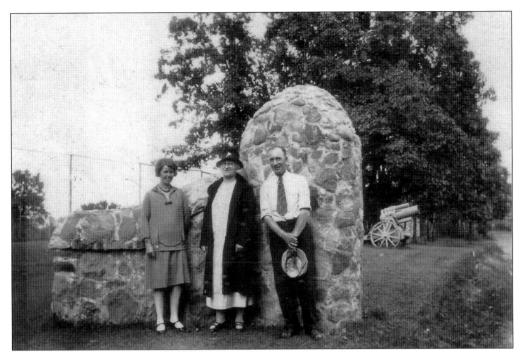

World War I German cannons were placed in the park in 1926, donated to the state by the US War Department. This artillery was to serve as a memorial to Iowa's deceased servicemen. It is unknown exactly how many cannons were located in the park, but there were three, possibly four. The McLaughlin family is shown here with a cannon near the country club entrance in the background. Another was located on the lower fairway of the golf course. The cannon below was located on the lower road, by the river. The cannons are now gone, salvaged for metal drives during World War II.

955
ON THE RIVER AT WAPSIPINICON STATE PARK

Plans to construct one of the largest outdoor swimming pools were announced in the autumn of 1926. A dam was constructed on Dutch Creek near the caves and the pool was officially opened in June 1928. The pool was 264 feet long by 108 feet wide with a depth of up to eight feet. The pool was fed by a series of fountains from the spring-fed creek, but a drought in 1931–1932 caused it to fail to be filled. The state closed the pool in 1934 citing health reasons. Indian Dam still stands as a reminder of the swimming pool and is still a popular attraction for park visitors.

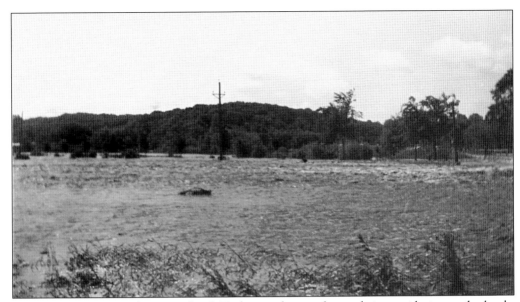

Where there is a river there is a flood. Each year the people watch in trepidation as the banks of the Wapsipinicon River disappear under raging water. In May 1947, the banks of the river disappeared under these flood waters. This view of the flood was taken downriver from the state park on Shaw Road. (Courtesy of Becky DirksHaugstead.)

Between May 2003 and July 2012, the crest of the river during flood stage reached a new level 13 times, the highest flood stage being set on June 13, 2008, at a record 26 feet. The flood water ravaged the southern end of town, covering the football field to a depth of 10 feet. The water poured almost two feet deep over the old iron bridge, something even the oldest residents could not recall.

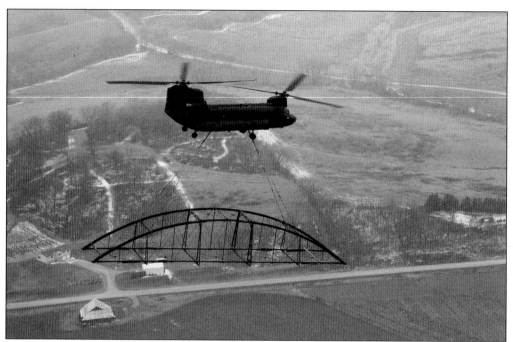

Wapsipinicon State Park made national news in 2003, when the Hale Bridge was relocated to the park by National Guard helicopters. The bridge had helped travelers cross the Wapsipinicon River in southern Jones County since 1879. Damaged by floods in 1993, it was closed to traffic in 1997. However, the bridge was nominated for the National Register of Historic Places in 1998 as the longest-standing bowstring arch bridge in Iowa. In 2003, it was moved to storage. (Courtesy of the Jones County Preservation Commission.)

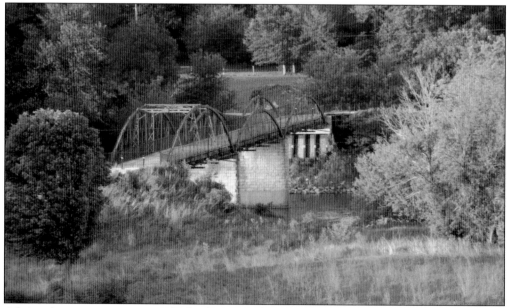

After a three-year restoration, the bridge was relocated 12 miles north to Wapsipinicon State Park on March 8, 2006, by the Iowa Army National Guard using CH-46 Chinook helicopters. It now serves as a pedestrian bridge. (Courtesy of the *Anamosa Journal-Eureka*.)

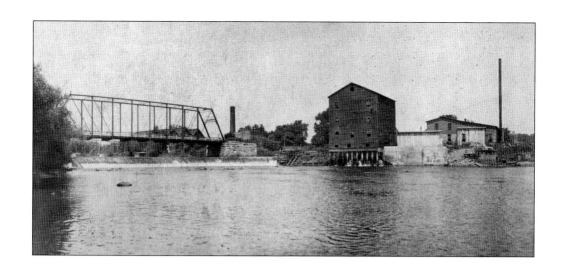

In 1840, Calvin Reed and a Mr. Jenkins built a dam and mill approximately where the current dam is located. As was often the case with these early structures, it was washed out by a flood a year or two later. In 1857, James Grahm, Horace C. Metcalf, and James Hudson built a new dam across the river. After one year's labor, they saw the large four-story mill completed in December 1857. By 1890, Metcalf had sole interest in the mill and dam and paid over $5,000 getting it repaired. The large mill structure was dismantled in 1910.

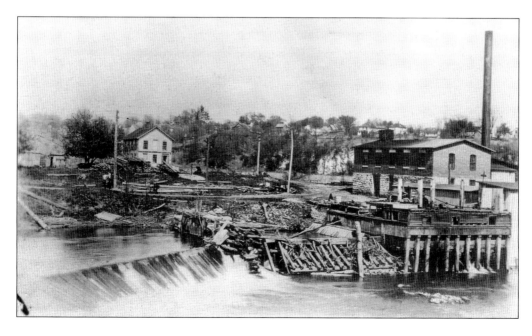

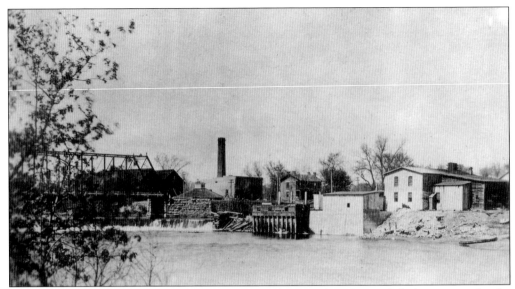

In 1893, Horace C. Metcalf and his son, C.W. Metcalf, started an electric light business under the name of Metcalf Light Company. The plant was located in the mill and ran on water power, with a steam engine as an auxiliary unit. In 1906, Harry Zinn and Park Chamberlin purchased the Metcalf Electric Company and consolidated it with the Oxford Junction Company. In 1912, the property was transferred to the Eastern Iowa Consolidated Electric Light and Power Company. In 1914, the company was incorporated into the Iowa Electric Company.

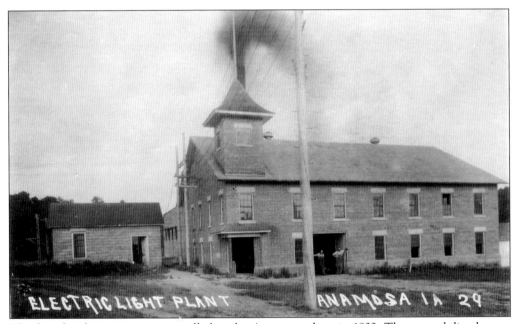

The first diesel generator was installed at the Anamosa plant in 1932. The second diesel came in 1935, and the last hydro-generator was installed in 1936. Lightning burned out this hydro-generator in the early 1960s and it was not replaced.

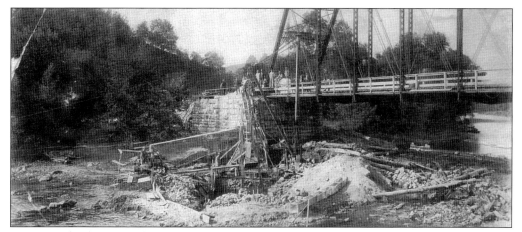

Repairs to the dam were always of interest to the townspeople of Anamosa. The dam was damaged again in the spring of 1900 when 60 feet were knocked out by "running ice." Repair work was completed in July of that year.

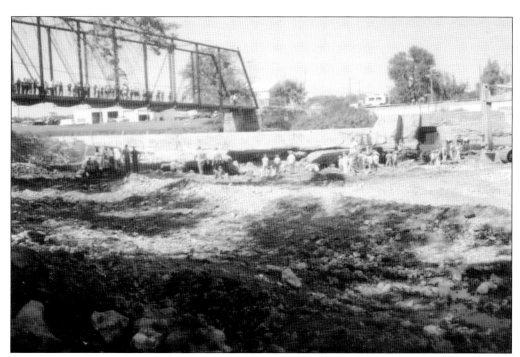

In 1985, when the present dam was being repaired, it was estimated that 2,000 to 3,000 people came to view the activities. After the water was lowered in the Wapsipinicon River to repair the dam just outside Anamosa, cracks became apparent in the center pier of the bridge over the river. Jones County and the city of Anamosa shared the $9,950 estimated cost of repair, since the center pier marks the middle of the bridge, which separates city from county jurisdiction. A large crowd watched the dam repairs and enjoyed the spectacle of large fish netted from deep holes and released downriver.

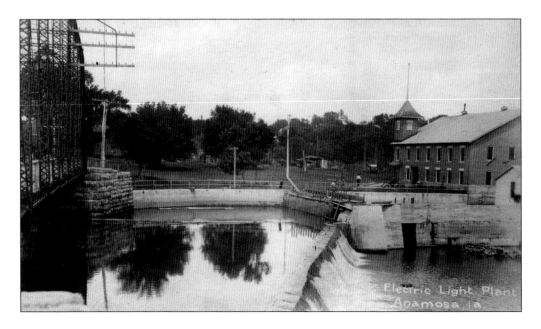

A story about the Iowa Electric Company is not complete without mention of the Meade family. Russ Meade worked at the power plant for more than 40 years starting in 1910, beginning the family tradition. He was with Iowa Electric for 43 years. In 1939, his son Jesse went to work at the plant. Jesse retired in 1980. Jay Meade, Jesse's brother, worked there for 16 years. Once, the plant was used to supply electricity for all of Anamosa, the reformatory, and Martelle when the demand for power exceeded the supply from Cedar Rapids.

Three

BACK DOWNTOWN

As with any small town, much changes while everything stays the same. Buildings that have stood for more than 150 years have housed several businesses, while generations of the same family have passed through its doors. Some businesses became outdated, the way horses gave way to cars, while others, like the newspaper, have stood the test of time because everyone still has a need for them. Anamosa's downtown has stood the test of time as well, its redbrick faces sometimes aglow with purpose and at other times dull with boredom. "Downtown" primarily runs east-west with a hook on the west that heads south. There is a spreading puddle of businesses to the east, "out by the highway." Unlike the pounding pulse of a big city, the sturdy heart of a small town beats at a slower pace with a warmth not found anywhere else. It is downtown where you see your friends and meet your neighbors. It is while getting a cup of coffee in the local shop that you hear of the latest accident, newest addition to a family, or the loss of a citizen. Not all downtowns are fortunate enough to have life after 100 years, much less 150 and even 175 years. There are many tales to tell about life downtown, fountains that became a park, a moving post office, runs on the bank, and always, people flowing along the streets.

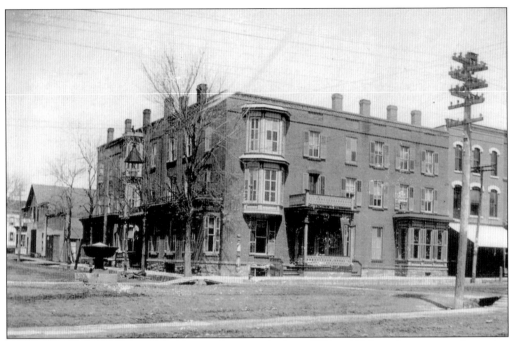

A prominent feature of most Main Street photographs from 1880 to 1920 are the watering fountains at the east and west ends of town. This image shows the fountain located at the intersection of Main and Garnavillo Streets. The fountain was placed in this location in 1879 and, as could be expected, caused issues with the traffic.

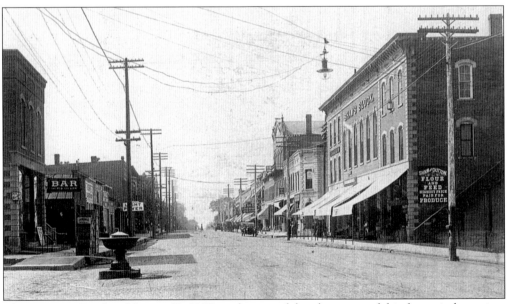

The *Anamosa Eureka* of August 18, 1887, made note of the placement of this fountain by saying, "The water was let into the new fountain last Tuesday. It stands at the intersection of Main and Cleveland streets and is about the same style as that near the Gillen House. The cost, however, was less, $35 being raised by subscriptions by Mr. Washington and about $70, we understand, is to be paid by the city. The two fountains are valuable conveniences."

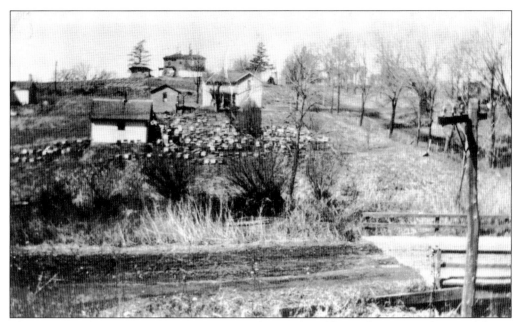

The watering fountains on Main Street were battered and bruised, outgrew their usefulness, and were eventually removed in the 1920s. Gone but not forgotten, one of them turned up in 1993 when Russell Ellison donated the one said to have stood at Garnavillo and Main Streets to the city. The fountain was placed in a park on the east side of the newly constructed Lawrence Community Center, thus giving the park its name. Fountain Park was established in 1993 from land donated by the Tom Snyder family. This area was formerly known as Snyder Apiary dating back to 1884. Frank Chapman Snyder started a honey business with bees he received in trade for a horse. His son Tom continued the business, maintaining an average of 180 hives. The photograph above shows the land as Snyder's Apiary; below is the same land as the newly constructed park. Today, Fountain Park is a riot of beautiful plants and flowers, paved walkways, a gazebo, and of course, the fountain as the centerpiece.

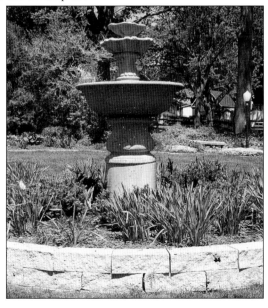

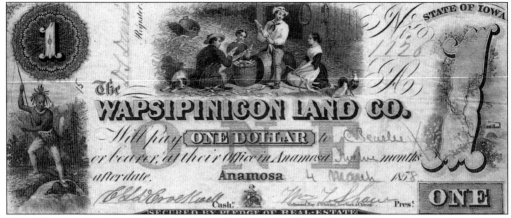

This Wapsipinicon Land Company note for $1 is dated March 4, 1858, and is signed by C.L.D. Crockwell and William T. Shaw. It is payable to C. Peaslee or bearer at the company's office in Anamosa. The Wapsipinicon Land Company was incorporated in Anamosa in 1858 during a time when "wild cat" currency was widely circulated. This scrip was used to help stimulate an economy that suffered from the lack of a consistent flow of hard currency, i.e., money backed by gold and silver. Although the Wapsipinicon Land Company incorporated with a capital of $500,000, only about one fifth of that amount was backed by hard cash. The rest was made up of scrip, supposedly backed by the company's land holdings. Long-time residents and businessmen William T. Shaw and C.L.D. Crockwell ran the company. Shaw was the president and Crockwell was the cashier. How long the company functioned as a quasi-bank is not known. (Courtesy of Kenny Humpal.)

Public Notice.

NOTICE is hereby given that a number of individuals have associated themselves and become incorporated agreeable to the provisions of the code of Iowa, under the name of

"THE WAPSIPINICON LAND COMPANY,"

and that its principal place of doing business is at Anamosa, in Jones County, Iowa.

The general nature of the business to be transacted by said company is the BUYING AND SELLING OF REAL ESTATE

The Capital Stock of the Company to be Five Hundred Thousand Dollars, one-fifth of which shall be actually subscribed and payment made thereon at such time as the Board of Directors may designate.

Said Company to commence business on the 18th day of January, A. D. 1858, and terminate on the 12th day of January, A. D. 1868, unless dissolved by a two-thirds vote of the stock subscribed.

The business of said Company to be conducted by a Board of Directors, consisting of five persons who shall be stockholders in the Company.

Said Board of Directors are appointed, by the Articles of Incorporation, to serve until the third Wednesday in January, A. D. 1860, at which time new Directors will be elected, and annually thereafter.

The greatest amount of indebtedness or liability shall not exceed two-thirds of the stock subscribed

The private property of stockholders shall be exempt from corporate debts.

Dated Anamosa, Jones Co., Iowa, January 18th 1858. 2n23w4.

This notice appeared in the *Anamosa Eureka* on May 10, 1858. (Courtesy of *Anamosa Journal-Eureka*.)

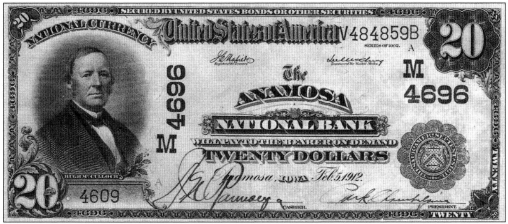

The Anamosa National Bank was established by Mr. C.H. Lull and others in 1891. The bank's initial capital was $50,000 and it featured a fireproof vault and a large safe. According to the *Anamosa Eureka* of October 15, 1891, "The gentlemen interested have abundant capital for the business and the public interests will undoubtedly be well served by this addition to our present valuable banking accommodations." Issued on February 5, 1912, this $20 note features the likeness of Hugh McCulloch, who served two nonconsecutive terms as US treasury secretary, and the signature of Park Chamberlain, president of the bank. Currency issued by the Anamosa National Bank was legal tender throughout the United States. The bank closed its doors in September 1937.

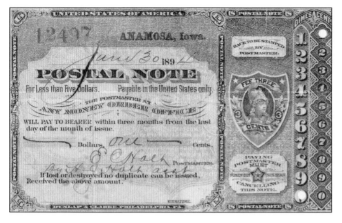

This postal money order dated June 30, 1894, is for the grand amount of 1¢, signed by postmaster Edward C. Holt. In 1876, under postmaster Harlen Hollenbeck's term, the Anamosa Post Office was made a money order office. Under the rules, a money order could be forwarded to persons in the vicinity of other money order post offices. The charge was 10¢ up to $20, and 25¢ for $20 to $50.

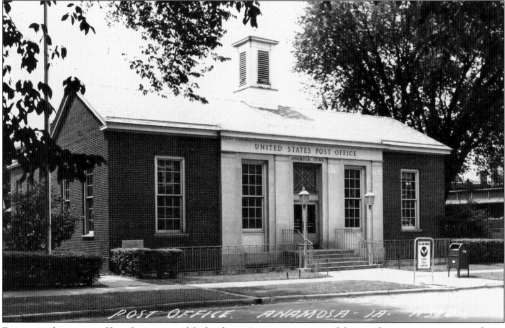

Prior to the post office being established in Anamosa, a weekly mail route was set up from Dubuque to Iowa City, passing through Edinburgh, Walnut Forks (now Olin), Tipton, and West Liberty. Edmund Booth often walked the 12 miles to Walnut Forks to get his eastern newspapers and mail. It was not until November 11, 1847, that a post office was established in Anamosa. C.C. Rockwell was the first postmaster. If a stranger came to town prior to 1904 and inquired about the whereabouts of the post office, he may have gotten one of 27 different answers, for it was moved with the appointment of each new postmaster. The current post office was opened in June 1941 and cost $75,000 to build. It was the idea of postmaster Charles J. Cash Jr. for it to have such grand style. Houses were moved from three lots and it was placed on an elevated base so as not to be dwarfed by the city hall. Hazel Cash served as acting postmaster when her husband was drafted for World War II until his return in October 1945.

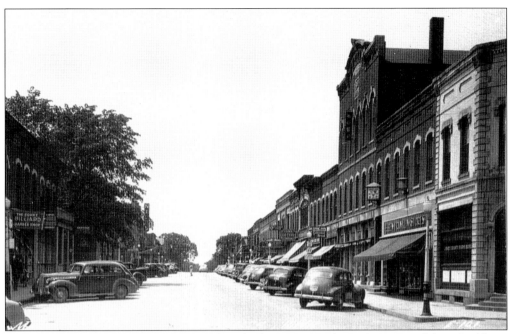

The north side of Main Street is shown here looking west in the 1950s. Most of these buildings were built by William T. Shaw, Lawrence Schoonover, E.M. Condit, T.R. Ercanbrack, and C.M. Brown in the 1880s. The exteriors have remained virtually unchanged through time even though the businesses inside have changed. The three-story Masonic Lodge building that dominates this side of Main Street was built by Shaw in 1881. The brick was manufactured locally and the limestone came from quarries in the area. The centrally placed stones feature the Masonic symbol, the date 1881, and the initials "A.F. & A.M." Some of the businesses on this side of the street were Cudworth's Hardware, the Ben Franklin Store, a Coast to Coast, Breon's Clothing Store, Mickies Model Shop, and Slate's Clothing Store. These buildings now house Kitty's Beauty Salon, the Starlighters Theatre, Tyler & Downing Eatery, Grant Wood Art Gallery, the chamber of commerce, Jones County Tourism, and Anamosa Floral.

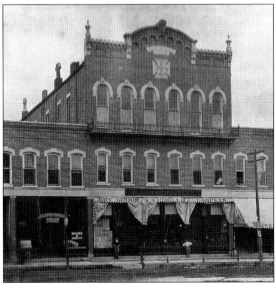

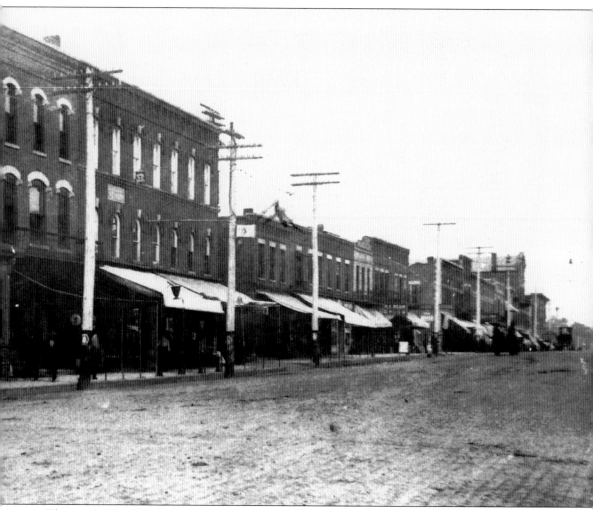

The north side of Main Street from Garnavillo Street to Ford Street contains some of the oldest buildings in town. The first two tall buildings have been razed and are now the location of F&M Bank. After the alley, the first two-story building is the oldest on Main Street. It was built by Horace Metcalf in 1863. The first business there was Alderman & Williams Grocery. Red Chipman's restaurant was later in the location and served alcohol from "under the counter." Now the location of Deb's Sports Bar, the service is quite open. The First National Bank building was constructed by Horace Metcalf in 1865. Metcalf later sold the building to William D. Gordon, who opened Gordon's Dry Goods Bazaar. Most recently the building was home to the offices of the *Anamosa Journal-Eureka*. The limestone-faced structure remains obvious on this block of buildings erected in 1866 by Richard McDaniel. Its initial businesses were drugstores. The first floor has since had its limestone covered, but the second story still shows the original veneer.

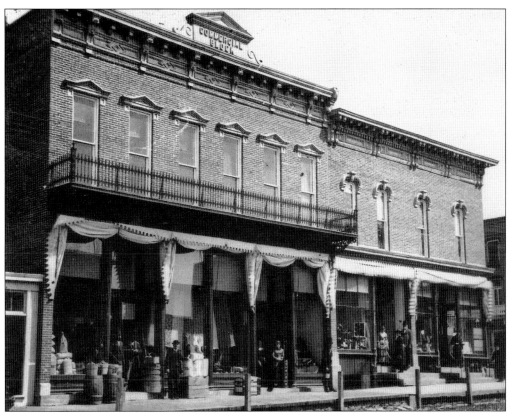

This block of Main Street stores is located on the north side of Main Street on the west side of Garnavillo Street. Originally known as the Commercial Block, the center building was constructed in 1881 by joint stock owners E.C. Holt, J.S. Belknap, O.E. Gillen, E.W. Gawley, Ebenezer Brown, W.M. Skinner, and C.W. Hollenbeck. The building to the east was erected in 1872 by Burrill Huggins and John S. Belknap. The building to the west was built by E.C. Holt in 1890. The Commercial Block in the center has always commanded attention, first with its skyward pointing sign and then the bright signs of Westphal's grocery store and later the Pamida Store.

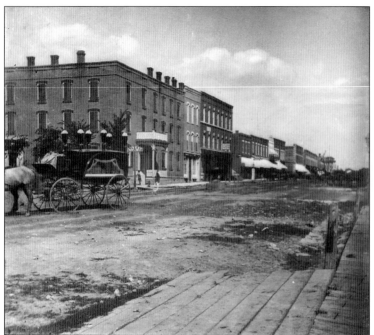

Unpaved roads and wooden sidewalks made up Main Street in this 1880s photograph of the north side of the street looking to the east.

Horse-drawn carriages and mud streets are shown in this 1880s view of the north side of Main Street looking toward the west.

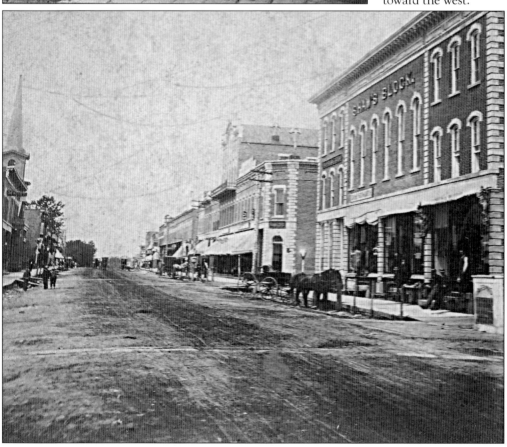

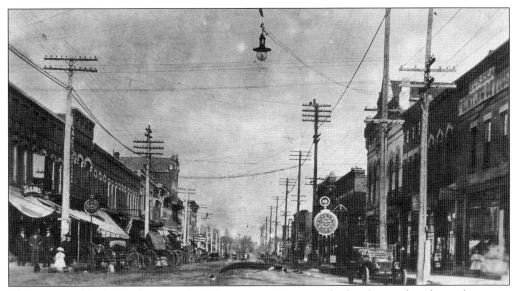

This eastward-looking photograph of downtown Anamosa looks cluttered with its electricity lines, cluster of buggies, and the newest mode of transportation, the automobile. By the 1940s, the automobile had completely replaced the horse and buggy, and the utility lines had been moved to the alleys behind the buildings.

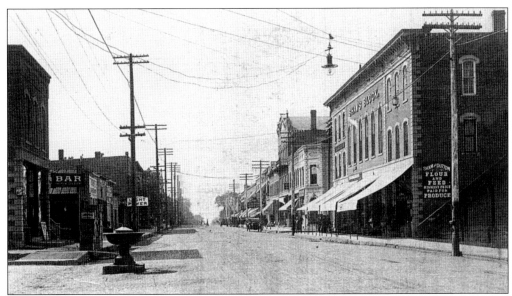

This photograph shows the opposite side of town looking to the west at about the same time. Not as many carriages are visible as the automobile was gaining in popularity.

Business was booming in the 1930s in this view to the east. These two theaters and the Opera House were the places to go for entertainment.

This section of Main Street, looking east from Ford Street, boasted clothing shops, drugstores, and grocery markets in the 1930s.

Four

RAILROADS

On August 25, 1857, the *Anamosa Eureka* wrote that the Dubuque Western Railroad had secured stock sufficient to complete the road to Monticello and that it was in want of $225,000 to complete the railroad through Anamosa, of which it hoped the people of Jones County could raise $94,000. The *Eureka* editor, C.L.D. Crockwell, urged, "If you are able, hesitate not one moment, but put your names down, and let us have the road immediately."

By December 1857, the Dubuque Western Railroad was working its way toward Anamosa. In spite of the progress made during 1858, Anamosa was not to see its first train until March 9, 1860. The train did not really make it all the way into town, stopping just north, opposite the Bishop Isabell home. The rails had not been laid all the way to the depot. The trip between Dubuque and Anamosa took four and a half hours.

In 1871, the Iowa Midland Railroad was complete, running 71 miles from Lyons, ending in Anamosa. The Midland tracks ran parallel on the south side of the Milwaukee tracks through town and then crossed over to the north at Ford Street, where they ran west to the penitentiary and on to the stone quarry.

The Midland had a turntable on which it turned the locomotives around for the trip back to Lyons, and there was also a roundhouse. In October 1884, the Chicago & Northwestern purchased the Midland.

The Dubuque Southwestern was sold to the Chicago, Milwaukee & St. Paul Railroad Company, better known as the Milwaukee, in early 1892.

The passenger train that gave Anamosa service to Chicago made its final run on January 3, 1903.

During the time between 1903 to early 1917, hauling freight kept Anamosa railroads busy. The Milwaukee received many carloads of freight from the Chicago, Anamosa, & Northern Railroad, known as the CAN. The CAN crossed Buffalo Creek six times between Anamosa and Fremont, a distance of five miles. The little 20-mile railroad operated until 1917. After the start of World War I, the equipment was sold, with the rails and bridges taken up for scrap to help the war effort.

The Midland branch of the Chicago & Northwestern Railroad was officially abandoned in 1950. By 1978, the Milwaukee Railroad had eliminated the line that served Anamosa.

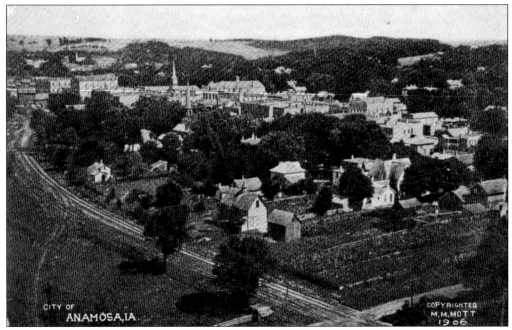

This view of Anamosa from 1906, probably taken from the tower of the penitentiary, shows on the left the railroads running on the north side of town. The track that veers off in the bottom corner leads into the prison.

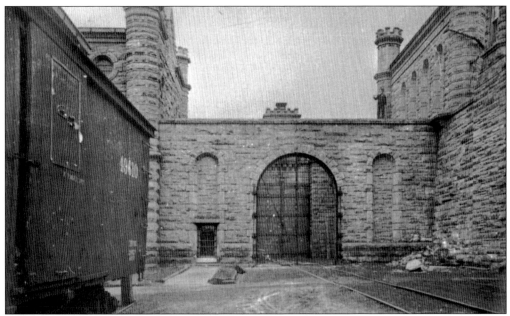

Any photograph taken of the south side of the penitentiary cannot miss including the train tunnel entrance. The train tunnel was eventually closed off, but the arch in the prison wall is still an iconic feature of the penitentiary.

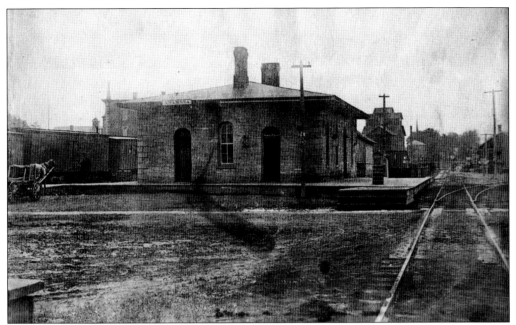

The passenger depot in 1891 was located just north of East Main Street. This limestone structure is now gone, as is the tall feed mill structure seen in the background. On March 25, 1901, eight cars of the eastbound freight train jumped the rails in Anamosa between North Ford Street and the passenger depot on Davis Street. The locomotive and other cars remained on the rails and there were no injuries.

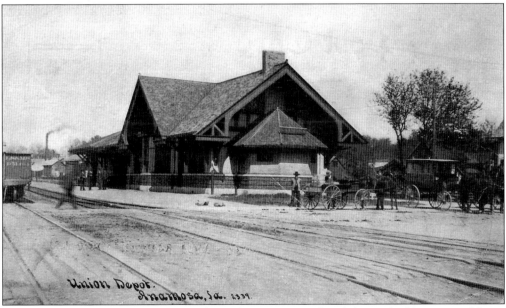

In the fall of 1905, the Milwaukee and Northerwestern Railroads began building a new Union Depot in Anamosa. It was built west of Davis Street at a cost of $10,000. With a foundation of Stone City stone, lower walls of brick, upper walls of adamant plaster in a straw color, and roof shingles stained red, it was a colorful facility. In the center were ticket offices for the Milwaukee and the Northwestern. There were two waiting rooms, smoking and nonsmoking.

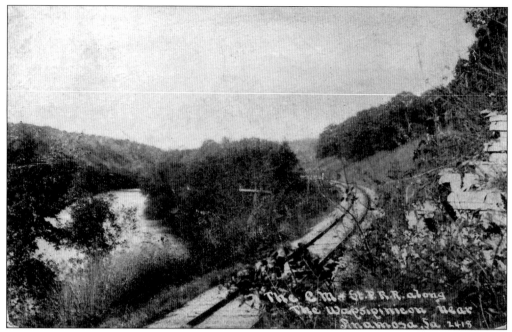

The route along the Wapsipinicon River and Buffalo Creek afforded scenic views to those who were fortunate enough to ride the rails. Things were not always pretty. Early in the winter of 1867, tragedy struck about three miles north of Anamosa. The locomotive *W.B. Allison* was derailed and thrown down a 10-foot embankment, where it landed wheels up. The engineer James Rolla and fireman Sears crawled out from under the overturned locomotive, badly burned by steam and scalding water. The forward wheels of the baggage and passenger car were off the rails, but no other damage was done.

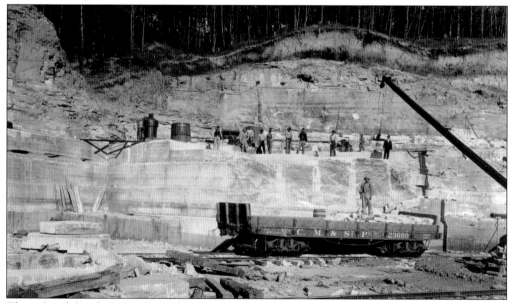

The railroads heading into Stone City were the carriers of limestone quarried there. The rails passed through the quarries, then headed east to Anamosa and onward to Cedar Rapids, Davenport, Chicago, and Milwaukee. (Courtesy of the Anamosa Historical Society.)

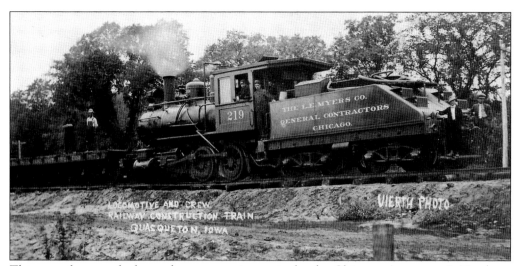

This rare photograph shows the construction train for the Chicago, Anamosa, & Northern Railroad, known as the CAN. Heading north to Prairieburg, the CAN rails crossed the Buffalo six times between Anamosa and Fremont, a distance of five miles including a deep cut through limestone. Completed all the way to Quasqueton, a bridge was never built farther north over the Wapsipinicon River, so the railroad never continued to Waterloo as hoped.

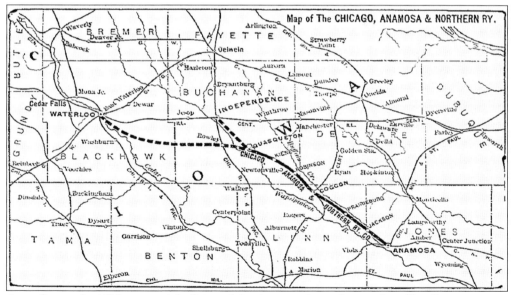

According to the 1938 centennial edition of the *Anamosa Journal*, more than $1 million was spent on the Chicago, Anamosa, and Northern Railroad, affectionately known as the CAN. This line was abandoned in 1916 and the rails were shipped to Europe by a Kansas City junk dealer. The route is shown here in heavy print: the dotted lines show proposed extensions to Independence and Waterloo. (Courtesy of the *Anamosa Journal-Eureka*.)

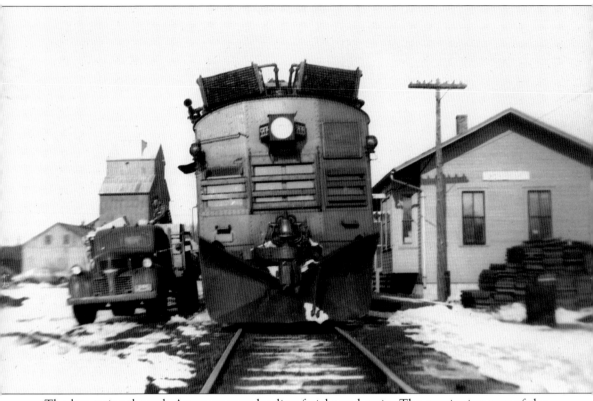

The last trains through Anamosa were hauling freight and grain. The continuing saga of the demise of the Milwaukee Railroad added a chapter in August 1977, with an Interstate Commerce Commission hearing in Anamosa on the proposed abandonment of the railroad's main and branch lines through Jones County. Administrative law judge Joseph May, of Washington, D.C., conducted the three-day hearing in the courthouse community room. The judge gave both sides, the railroad and shippers, until October 30 to file written briefs. Judge May then had until February 1979 to approve or deny the proposed abandonment of the line. Milwaukee Railroad officials said the bankrupted railroad lost over $38 million in 1977 and wanted to abandon the lines because they were not profitable. Officials also said 95 trips were made by trains on the line in 1977, moving in 150 cars and taking out 437. The railroad estimated it would take $6.4 million to bring the track to Class II standards. Over a dozen shippers, however, said loss of rail service would cost them money and put them in a less competitive position. By 1980, the sound of trains passing through Anamosa would no longer be heard.

Five

CHURCHES

Churches in and around Anamosa have always been vigorous and plentiful. As described in the 1879 *History of Jones County*, men of God came to the area from its inception, and the families who settled here kept their own faith strong, worshipping in their homes until churches were built.

About 1840, Rev. Thomas Emerson spread the good word throughout the county, which included the whole of Fairview, Greenfield, and Rome Townships. His labors, though brief, were attended with some success. Reverend Rankin was the next to come into the area with a view of organizing a Christian church, but finding the project beset with many difficulties, he left it unaccomplished.

Soon after this, about 1844, Rev. E. Alden Jr. succeeded in gathering and organizing a small Congregational church in Rome (now called Olin), which is thought to be the first church organization in the county. But it was of brief duration. Discordant elements arose, and the church was dissolved early in 1846.

In the spring of that year, Rev. Alfred Wright visited as a missionary; the following September he moved to Anamosa, which was then known as Lexington. Reverend Wright was successful in organizing a Congregational organization, which remains in Anamosa to this day.

The Methodists established what was known as the Anamosa Circuit in 1849, and the Reverend Vail was sent as their first representative.

Churches grew in number as Anamosa grew, and by 1893 there were six in town: Presbyterian, Congregational, Baptist, Methodist, Catholic, and Episcopal. More than just a place to worship, churches cared for the poor and kept public records of marriages and deaths. Meetings were held in churches, which were also used as community centers for courtship, socializing, and sharing news.

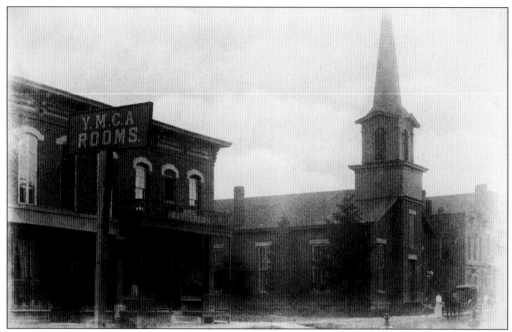

The First Congregational Church is one of the oldest organized churches in Jones County. Began on November 14, 1846, the first meeting was held in a log cabin in the original west side of town by Rev. Alfred Wright, a missionary from Missouri. In 1852, a frame church was built on what is now South Main Street. Edmund Booth donated the land on the corner of Booth and Main Streets, and a new brick church was completed on December 29, 1861.

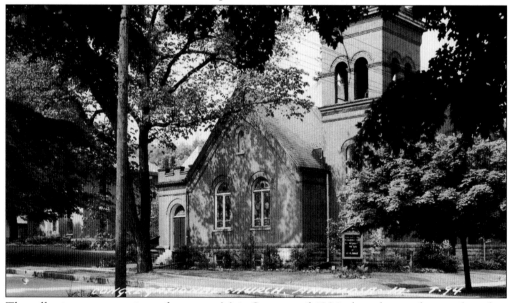

The tall spire was a prominent feature on Main Street until 1904 when the new house of worship was completed on the corner of First and Booth Streets. A beautiful pipe organ featuring 596 pipes was installed and is still played today. During 1958, the educational building was added to the south end of the church. The matching brick parsonage for the church faces east on Booth Street on the south side of the church.

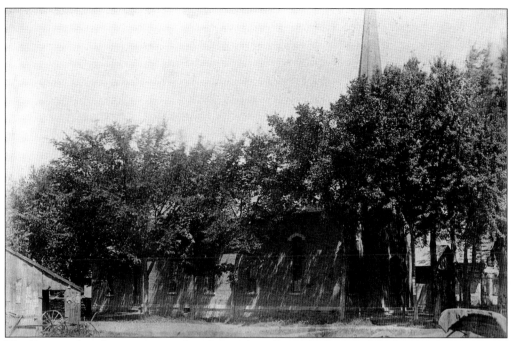

The Baptist church was organized on June 26, 1858, in the home of Eliphet Kimball. In 1868, this church was erected on North Garnavillo Street. It was 40 feet by 60 feet with high ceilings and a bell tower. The cost of the building with the lot was $5,725.

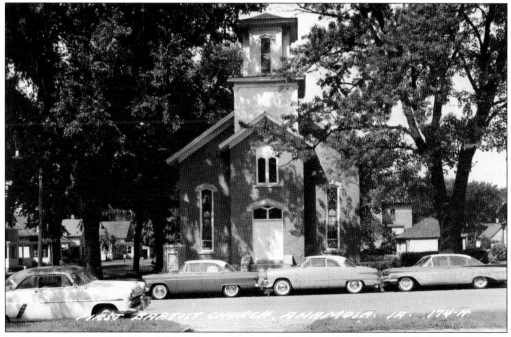

In 1886, a substantial brick addition for meetings and Sunday school was built. In 1965, a 32-foot-by-55-foot addition was built west of the church to house a nursery, classrooms, a pastor's study, secretary's office, kitchen, and fellowship hall. Now this little church is gone.

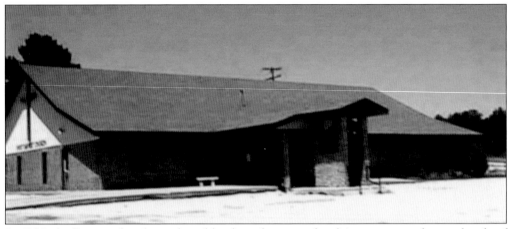

In 1986, the Baptist church purchased land on the east side of Anamosa, on the north side of Third Street, just east of Roland Street. First Baptist is still thriving, having been a part of the community for more than 150 years.

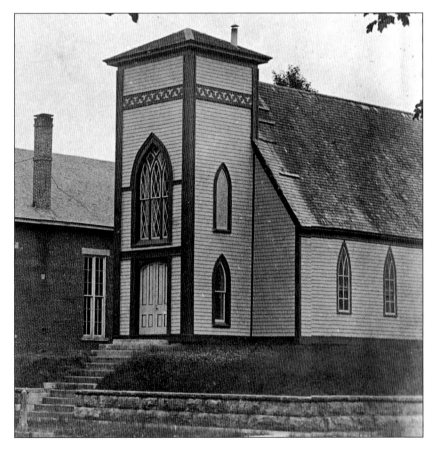

St. Mark Episcopal Church was organized on August 14, 1859, under Rev. Walter F. Lloyd. The church was completed in July 1860, located on the corner of First and Garnavillo Streets, which at that time was called Lovers Lane.

For a time, the rectory for the St. Mark Episcopal Church was located on the southwest corner of South Ford and Second Streets.

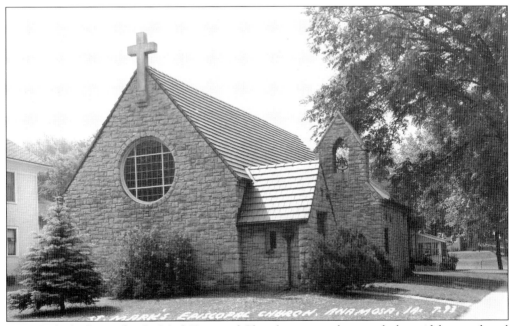

In 1928, the little wooden St. Mark Episcopal Church was torn down and a beautiful stone chapel was built, largely as a result of bequests from Mrs. Peter Meyer. This beautiful stone chapel still stands and is used for services.

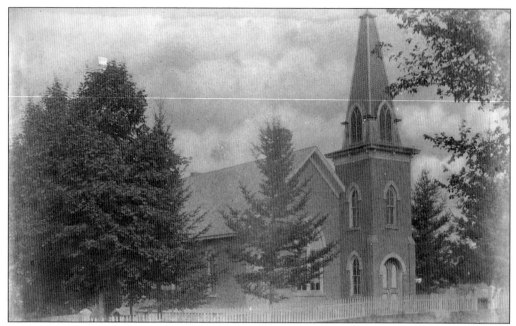

The First Presbyterian Church of Anamosa was organized on September 20, 1868, by Rev. James McKean and Rev. J.L. Wilson. Meetings were held in the Baptist church or in Miller's photograph rooms downtown. The church was served by traveling ministers until 1871, when the church secured Rev. J. Nesbitt Wilson for three successive years. After that time, until the spring of 1878, the church was supplied about once a month by Rev. H.L. Stanley. In the spring of 1878, the place of worship was removed to Strawberry Hill Schoolhouse, where services were held until the completion of the church building on November 17, 1878. Col. William T. Shaw generously donated to the church one-half of a block of lots. The brick building was 28 feet by 48 feet with an ornate 60-foot high tower on the northeast corner. The bricks were by B.F. Smith from his kilns on Strawberry Hill. The church was elegantly trimmed with Anamosa limestone. This little church was lost to a fire in 1903.

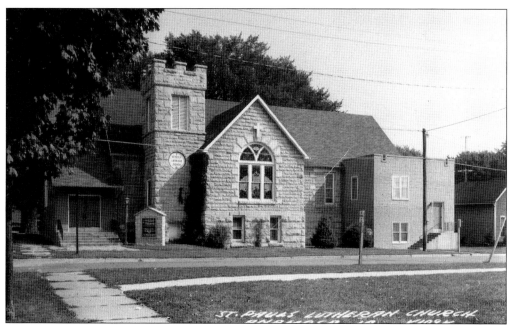

This stone church was built on the northeast corner of North Ford and Cedar Streets by the Presbyterians after their Strawberry Hill church was destroyed by fire. On December 17, 1914, when the Anamosa Presbyterians grew too few in number to maintain the church, it was purchased by the Catholic guild, which called it "Power's Court" after Fr. Robert Powers. It was used for Catholic services for a time between 1926 and 1929. St. Paul Lutheran Church was organized as a congregation on August 29, 1923. It took over the little limestone chapel in 1931 for $4,000. In the beginning years, services were held alternating between English and German. The Lutheran church was completely remodeled in 1954. A new parsonage was built in 1958 on the old parsonage lot just south across Cedar Street, then the educational unit was built in 1965 on the same lot. St. Paul Lutheran Church still holds services in the stone chapel today.

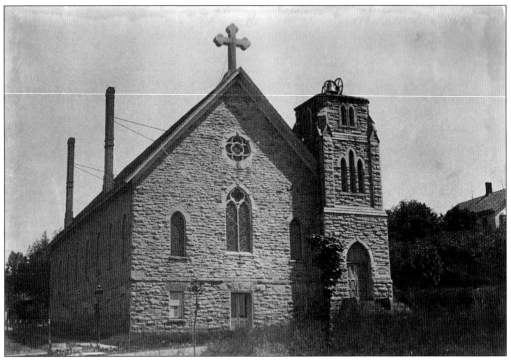

The first Catholic church was a small brick structure, 30 feet by 50 feet, built by the parishioners and used until 1875. Then this large edifice, shown as it looked in 1891, was built on the corner of High and Broadway Streets at the top of the hill. The sanitarium had not yet been built. This church was used until March 29, 1926, when it was destroyed by fire.

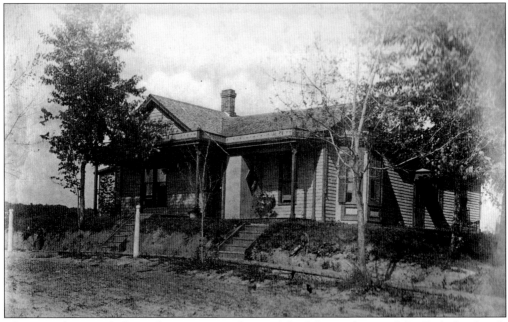

This 1891 photograph shows the convent residence of the father and nuns of the Catholic church located at the top of High and Broadway Streets.

After the Catholic church burned, Father Eardley sought a more central location and purchased the site at the intersection of North Garnavillo and Carroll Streets. This new church was dedicated on May 27, 1929, and is still in use today

St. Patrick Catholic Church also maintains the Holy Cross Cemetery on the northwest side of town and the St. Patrick Elementary School directly across the street from the sanctuary.

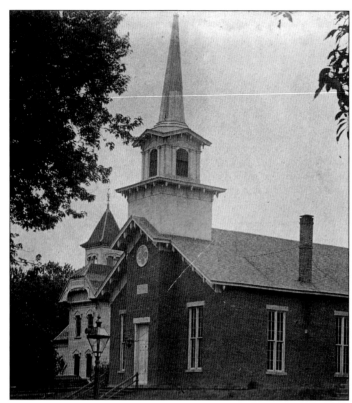

The first Methodist Episcopal Church was organized in Anamosa in 1851 by Reverend Vaile. Initially, the small congregation held its services in a variety of places in the original settlement where South Main and Hickory Streets are today. In 1861, when the Congregational church moved to Main and Booth Streets, the Methodists paid $100 for the little frame church on South Main. In December 1865, the redbrick church with a tall white steeple was dedicated. It was located on First Street in the middle of the block between Garnavillo and Ford Streets. The cost of the building was $5,697.15. The bell was installed in 1867.

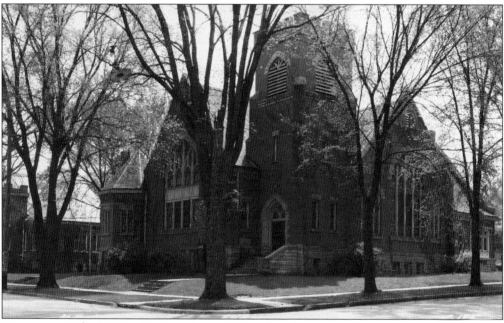

The current United Methodist Church was dedicated on June 27, 1907, built under the guidance of Rev. D.C. Dutton. The new building cost $32,000 and had the bell from the old structure moved into it. Added to this impressive structure in 1964 were six classrooms, a pastor's office, a secretary's office, and a fire-resistant vault. It was dedicated on May 16, 1965, and still serves the community.

Six

HEALTH CARE, HOSPITALS, AND DOCTORS

Anamosa is fortunate to have its own health care facility that has lasted through the years. A key to survival is the ability to adapt and change.

The first Anamosa hospital building was constructed under the direction of Rev. Robert Powers. It was to be a mother house for the Sisters of St. Francis. In the early 1890s, the Sisters of St. Francis moved to Clinton. Originally called Prospect Park Sanitarium, a permit was given to Dr. D.W. Gawley to convert the stone building into a sanitarium, an institution for the preservation of health. He served as administrator of the facility. Unfortunately, on January 28, 1902, a fire destroyed most of the building. Using donated money along with the insurance benefits from the fire, the sanitarium was rebuilt by December 1903. The Sisters of Mercy continued to take care of the hospital and its patients. A training school for nurses was in operation at the facility from 1918 until 1930.

By the end of 1946, the hospital needed to be modernized to keep up with patient needs. The Sisters of Mercy hoped to build a new facility rather than remodel. In late 1950, a remodeling project was completed, and the Sisters of Mercy continued to serve the community in the old stone building.

New standards from the State Department of Public Health in 1961 made the hospital unable to meet the qualifications for an acute care facility. The sisters voted to withdraw from the Anamosa facility, but a fund drive started by the community leaders brought in enough funds to build a new hospital to be managed by the Sisters of Mercy. Construction began in 1964 and the new hospital was completed on December 13, 1965.

In January 1974, Dr. John Bailey and Dr. Gerald Brown moved to newly constructed offices in a two-story building adjacent to the hospital. They named the new offices the Broadway Medical Clinic.

In 1982, the Sisters of Mercy were forced to terminate their administration of the hospital because fewer sisters were entering the medical profession. St. Luke's Hospital in Cedar Rapids entered into a management agreement with Anamosa Community Hospital. In 1999, Anamosa Community Hospital changed its name to Jones Regional Medical Center to better reflect the fact that it was offering medical services to the entire Jones County community. Jones Regional Medical Center opened the doors of its new almost $3-million facility on October 13, 2009.

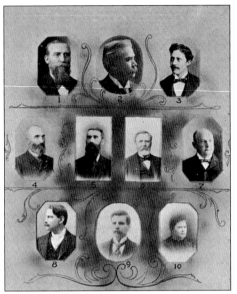

These were the doctors of Anamosa as published in *Picturesque Anamosa*. Progressive for the time, a woman was also listed in that profession. Doctors shown in the photograph are M.P. Sigworth, S. Druet, T.C. Gorman, H.W. Sigworth, J.M D Joslyn (Joslin), L.J. Adair, Wm. T. Makay, J. E. King, R.H. Gray, and Nettie Gray.

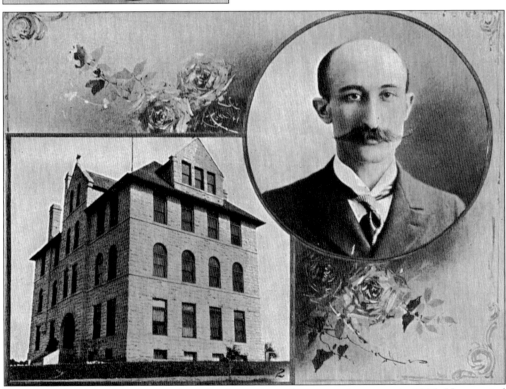

Dr. Aram Garabed Hejinian was born in Armenia and came to Anamosa in 1896. He married Bertha Stacy in 1898. They had two children: Lucea, who married a Mr. de Kiewiet of Iowa City, and John, of New York City. Dr. Hejinian was the surgeon in charge of the Sanitarium in 1900. He was a member of the Jones County, Iowa Union, and Iowa state medical societies and the American Medical Association. He was also one of the original stockholders of the Citizens Savings Bank of Anamosa and was on its board of directors. Dr. Hejinian died at his home in Anamosa on July 5, 1934, at the age of almost 71 years.

An old advertisement describes the sanitarium as "A magnificent stone building with all modern improvements located in the high tonic atmosphere. Spacious and well ventilated rooms, steam heat in every room, rates are very low."

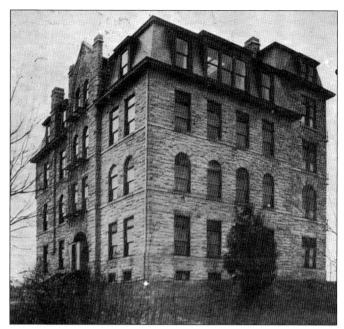

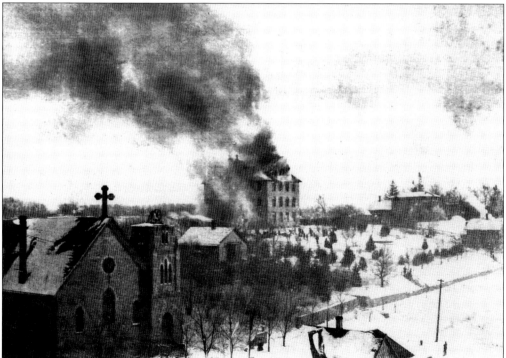

Unfortunately on January 28, 1902, a fire destroyed most of the building. Only the walls and a portion of the lower story were left standing. The fire was caused by cinders dropping on the roof from one of the chimneys. Patients were taken to private homes without incident. Later that year, Archbishop Keane spearheaded the effort to rebuild the sanitarium by donating $500 to the cause. Matching donations soon came from the Honorable J.A. Green, Col. W.T. Shaw, Dr. T.C. Jomain, Dr. Sigworth and sons, and Dr. A.G. Hejinian.

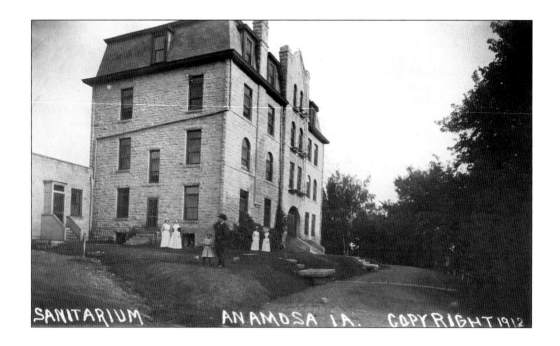

SANITARIUM ANAMOSA IA. COPYRIGHT 1912

Reconstruction was soon underway. After the sanitarium was rebuilt in December 1903, the Sisters of Mercy purchased the new four-story sanitarium along with 10 acres of land for $14,000. The mortgage was satisfied in 1914. During that time, the name was changed from Prospect Park Sanitarium to Mercy Hospital. In 1916, a four-story, 46-foot-by-20-foot addition was built on the east side at the cost of $16,000.

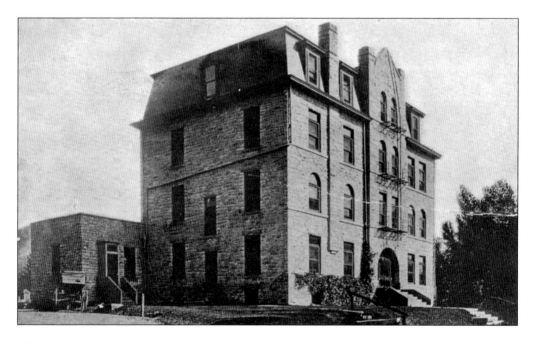

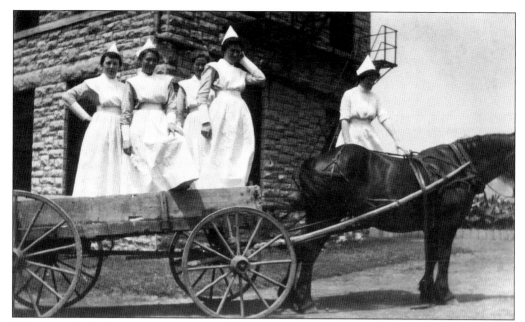

This wagonload of nurses was identified as including Miss Moran, Miss Hartwig, Miss Cranny, Miss Shaffer, and Miss Sullivan, superintendent.

In 1918, World War I caused a shortage of nurses, so a training school was started at the sanitarium. There were only three ladies, Thelma Ingraham, Helen Porter, and Ruth Turner, in the last graduating class of nurses from Mercy Hospital on May 19, 1930. Altogether, 60 nurses had graduated in 11 classes from the hospital school.

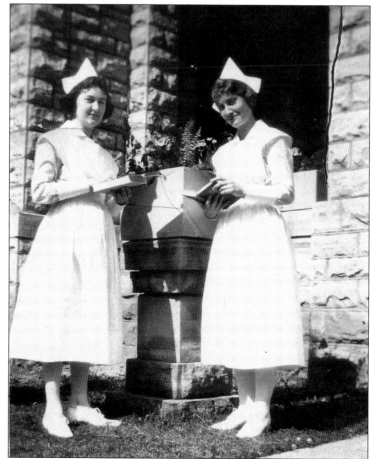

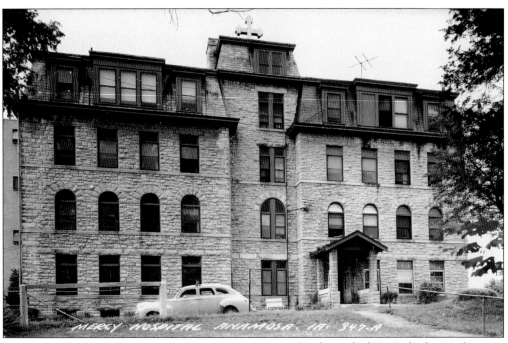

STATEMENT

IN ACCOUNT WITH

MERCY HOSPITAL

ANAMOSA, IOWA, April 20, 19 50

To _____

Anamosa, Iowa

DESCRIPTION	CHARGES	
BALANCE ACCT. RENDERED	$	
ROOM AND CARE Ad: 4-11-50		
Dis: 4-20-50 9 days @$8.50	76	50
OPERATING ROOM	20	00
DELIVERY ROOM		
CARE OF INFANT		
X-RAY		
DRESSINGS	1	50
DRUGS	1	60
LABORATORY FEE AND PATH. EXAM.	6	50
SPECIAL NURSE BOARD		
ANESTHETIC Agents	4	50
CAST		
Anesthetist Fee	15	00
XLAUNDRY CHARGESX Duracillin	6	00
Spec. tissue to C. R. for examination	5	15
TOTAL	$ 136	75
CREDITS Discount	13	75
Sisters of Mercy BALANCE AMOUNT DUE	123	00

PRIMES & SONS, POCATELLO, IDAHO FORM 8015

By the end of 1946, the hospital needed to be modernized to keep up with patient needs. The Sisters of Mercy hoped to build a new facility rather than remodel and agreed to donate 50 percent of whatever amount was collected by the people of the community. Two fund drives were attempted, one for $100,000 and another for $150,000, but neither was successful. In late 1950, a remodeling project was completed, and the Sisters of Mercy continued to serve the community from the old four-story building.

This patient had to have surgery for an unknown illness in 1950. The total bill, which included a nine-day stay, was $123. In 1949, a total of 1,150 patients were admitted and 307 babies were born. The cost for caring for patients averaged $10.60 per day. (Courtesy of Ken Humpal.)

Dr. J.D. Paul started his medical practice in Anamosa in 1914. In 1944, he purchased the building at 117 East Main Street, which he remodeled for use as a doctor's office. On September 1, 1946, Dr. Paul's son Dr. Robert D. Paul joined his father, staying until 1951. Dr. Gerald F. Brown became associated with Dr. J.D. Paul on October 1, 1952. In the summer of 1956, Dr. John L. Bailey, an Anamosa native, joined Drs. Paul and Brown in the remodeled offices on Main Street. Dr. Brown purchased the Main Street building after Dr. Paul died of a heart attack in 1964. In 1982, Dr. Geoffrey Miller Joined Dr. Bailey when Dr. Brown decided to retire. In 1986, Dr. Charles Vernon became an associate of Drs. Bailey and Miller. Dr. Brown suffered a severe stroke and passed away in August of 1986. Dr. Vernon continues his medical practice to this day.

Dr. Aaron Peter Randolph Sr. worked at the medical practice in Anamosa for 34 years, from 1956 to 1989. He claimed to have delivered more than 1,500 babies. He passed away on August 31, 2009, at the Anamosa Care Center.

Dr. Randolph is pictured here speaking with one of the Sisters of Mercy outside of the hospital.

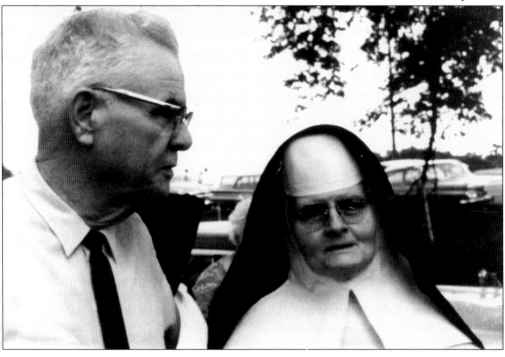

It appears the senior nurse is giving this new nurse instructions on the care of babies in the nursery.

Two nurses are seen here working with some of the equipment in Mercy Hospital in 1957.

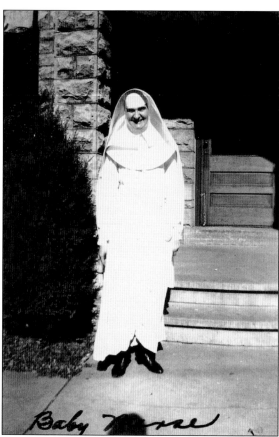

This Sister of Mercy was identified as Sister Julian on the back of this 1957 photograph, but as the "Baby Nurse" on the front.

Keeping up with the paperwork with all of the latest 1950s equipment, this Sister of Mercy has a telephone, files, and a typewriter all conveniently located around her.

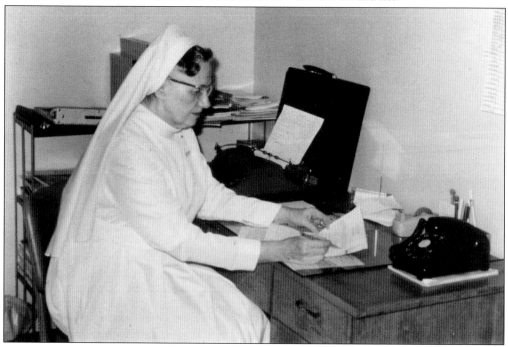

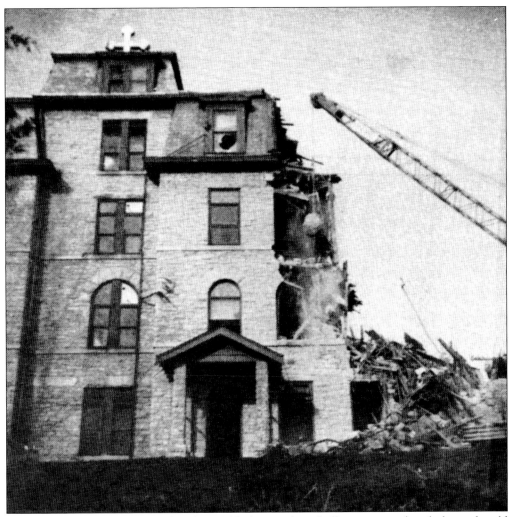

After a new hospital was completed in 1965, the wrecking ball came in and took down the old four-story Mercy Hospital building.

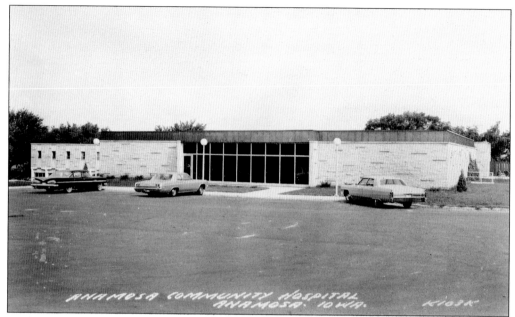

With a successful drive to finance the $600,000 facility, construction began in 1964 for the new 38-bed hospital. It was completed December 13, 1965, as the Anamosa Community Hospital.

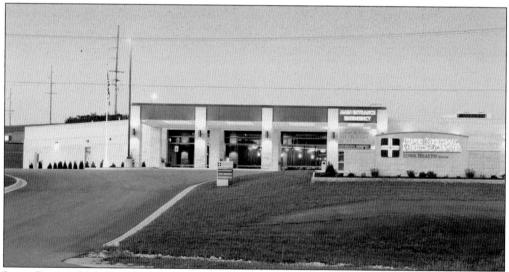

Jones Regional Medical Center opened the doors of its new facility on October 13, 2009. The facility accommodates 22 inpatients with state-of-the-art patient beds in a home-like setting with private bathrooms. Private rooms are available for up to the first 15 patients, after which double rooms are used.

Seven

FAIR TIME

The first fair known to be held in Jones County was in Bowen's Prairie in 1853. Enterprising residents of the county planned a county-wide picnic for a day, which would also give them a chance to display, study, and compare the fruits of farming in all phases.

The second fair was held in Rome Township on a site near Olin in September 1854. It was thought, at the time, to be worthy of the county.

The next year, 1855, the fair was set up in Anamosa. This was the first recorded exhibit in the county. Held where the penitentiary is today, a few stakes connected with rope held the livestock. Households and gardens were represented by a few quilts, blankets, some sorghum molasses, vegetables, and locally grown apples. For the finale, fun-loving farmers drove their wagons around spectators at top speed.

In 1856, the fair was again held in Bowen's Prairie, and then it was back to Anamosa in 1857. That year, James Peet was awarded $10 for the best cultivated farm in the county.

Starting with the outbreak of the Civil War and years of rainy weather, the fair declined until it was no longer held by 1873.

The next fair in Anamosa was in September 1884. It had displays of quilts, fruits, flowers, and breads with a show of hogs, sheep, and fowl. Trotting and running horse races were held, with entertainment provided by the Norwegian Band.

In 1895, an amphitheater was built to hold 10,000 persons. Horse stables were moved to the south side of the fairgrounds and trees were planted to make a shady park.

An estimated 15,000 people attended the 1902 fair. There were food and lemonade stands, shows, a merry-go-round, and a Ferris wheel.

In 1926, the stables were destroyed by a grass fire but were rebuilt.

A chain of circumstances permanently closed the Anamosa Fair. Association officers were perplexed for years to find a date with ideal weather conditions, so the fair moved from August to October seemingly at whim. The "rain jinx" haunted the last 20 years of the show's existence, but perhaps the most striking blow occurred in 1931 when a fire destroyed both sections of the amphitheater.

On February 4, 1932, an *Anamosa Journal* headline read "May Abandon Anamosa Fair" and information was given about a stockholders' meeting and the division of funds.

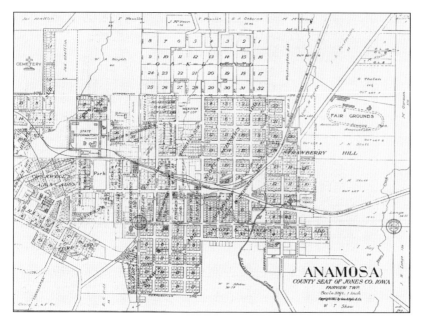

For a new location for the 1859 fair, William T. Shaw donated, rent-free for 10 years, some of his land just east of Anamosa and north of Strawberry Hill. This location was eventually purchased by the Anamosa Fair Association and was used until the fair's demise.

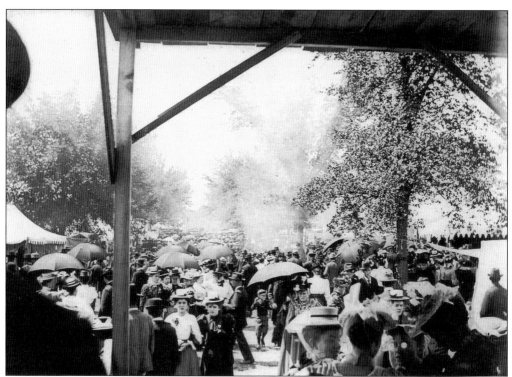

The Anamosa Fair was a sea of hats, umbrellas, and faces in this 1887 photograph of the crowd. The newspaper urged that "Every intelligent and progressive farmer of Jones county, together with his wife and family, should take a few days rest next week and attend the fair." From the looks of this photograph, they did.

This complimentary ticket allowed a child under the age of 14 into the fair free on August 18. The 1897 fair was held August 17–20 and the *Anamosa Journal* reported that "The question of weather was a dubious one Monday and Tuesday. Monday was unreasonably cold, a snap in August that is seldom met with good attitude."

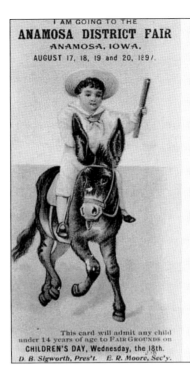

I AM GOING TO THE
ANAMOSA DISTRICT FAIR
ANAMOSA, IOWA.
AUGUST 17, 18, 19 and 20, 1897.

This card will admit any child under 14 years of age to FAIR GROUNDS on **CHILDREN'S DAY, Wednesday, the 18th.**
D. B. Sigworth, Pres't. E. R. Moore, Sec'y.

Never Equaled in Iowa!

Will be the unanimous verdict when the Attractions for 1897 are seen at the

ANAMOSA FAIR

TWO DIVING HORSES.

"Powder Face" and "Cupid" will Dive from a 40 Foot Tower into a miniature lake. Diving Head First, like a human being, each day.

DR. W. F. CARVER.

Champion Shot of the World in his Wonderful Exhibition of Rifle, Shotgun and Horseback Shooting, daily.

BASE BALL.

Each Day of the Fair by the Best Clubs in Iowa.

Special Attractions for Children's Day that will interest young and old alike

$1,600.00 FOR HORSE RACING.
$1,000.00 FOR SPECIAL ATTRACTIONS.

The Grounds have been enlarged, as the Fair has outgrown the Grounds. New Barns have been erected. Track Record, 2:16¾ in 1896. Purses paid from Judges Stand at the close of each race. You will always regret it if you miss the

ANAMOSA FAIR

this year. OVER

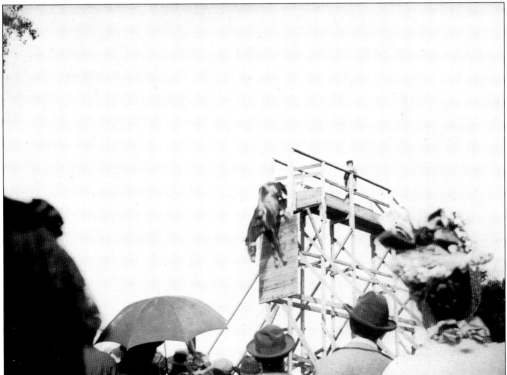

While exact identification of the horse has not been accomplished, the August 19, 1897, *Anamosa Eureka* reported that the miniature lake into which the diving ponies made their drop is filled after five days' continuous play and that the ponies are quartered in the stalls at the fairgrounds.

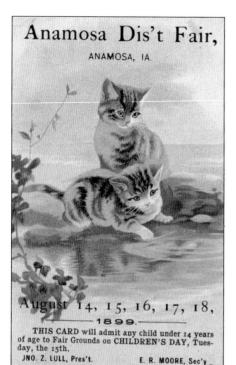

Anamosa Dis't Fair,

ANAMOSA, IA.

August 14, 15, 16, 17, 18,
—1899.—

THIS CARD will admit any child under 14 years of age to Fair Grounds on CHILDREN'S DAY, Tuesday, the 15th.

JNO. Z. LULL, Pres't. E. R. MOORE, Sec'y

This ticket for free admission to the Anamosa Fair on Children's Day could be obtained at the office of the secretary, E.R. Moore, any Saturday morning from 8:00 to 10:00, according to the June 8, 1899, edition of the *Anamosa Journal*.

The 1902 tickets were given away early enough that the exact attractions of the fair had not yet been determined. It was reported that one or two shows turned out to be of questionable character, and a newspaper editorial suggested to the association that there be a clearly understood agreement with parties engaging in concessions, so that if their performances were objectionable they could be compelled to leave the grounds.

ANAMOSA FAIR.

ANAMOSA, IOWA.
AUGUST 25, 26, 27, 28, 29, 1902.

ROSE BEAUTY

This card will admit any child under 11 years of age to FAIR GROUNDS on CHILDREN'S DAY, TUESDAY, the 26th.

F. J. CUNNINGHAM, E. R. MOORE,
President. Secretary.

Anamosa Fair

Greatest Attraction Fair in the
...United States...

Announcement of Attractions will be made later. Some have been engaged and many others will be engaged. While many Fine Attractions have been presented at the ANAMOSA FAIR in former years, this year will excel all others in Excellence. Variety and Number of Attractions. Between 40 and 50 people will perform upon the 40 foot stage in front of the Amphitheatre. $2000 will be expended in special Attractions. Do not go elsewhere to see the Greatest Fair in the State. Anamosa will hold such a Fair.

..Base Ball..

In addition to the Great Attraction upon the Stage, Base Ball will be played each afternoon of the Fair between the best clubs in the State.

$2500 in Purses.

$2500 will be given for Trotting, Pacing and Running Races.

When your friends return home and tell you what a Great Fair they have attended, you will have reason to regret it if you do not attend.

(OVER.)

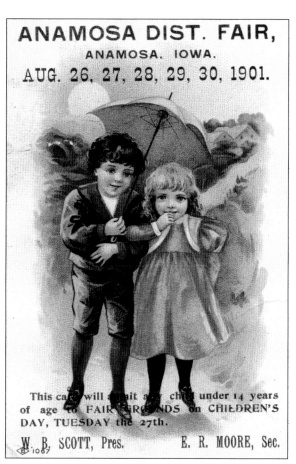

ANAMOSA DIST. FAIR,
ANAMOSA. IOWA.
AUG. 26, 27, 28, 29, 30, 1901.

This card will admit any child under 14 years of age to FAIR GROUNDS on CHILDREN'S DAY, TUESDAY the 27th.

W. B. SCOTT, Pres. E. R. MOORE, Sec.

Fair tickets were not always the same, as proven by these two distinctive styles for the 1901 fair. A big attraction were the baseball games played during the four days of the fair. The 1901 fair boasted 16 games between eight different clubs. One of the other highlights of the Anamosa Fair that year was a baby exhibition, open to any babies born since the last fair. A solid gold ring set worth $5 was given to the best-looking baby. A solid gold diamond ring was given to the largest baby born. The baby exhibit was held on Friday, the last day of the fair.

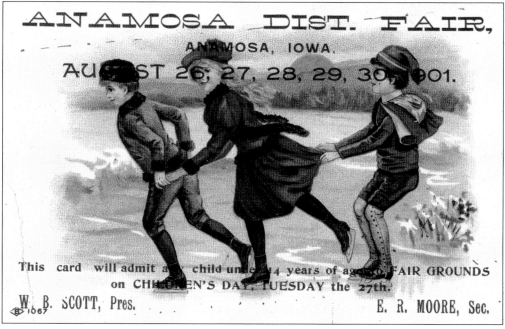

ANAMOSA DIST. FAIR,
ANAMOSA, IOWA.
AUGUST 26, 27, 28, 29, 30, 1901.

This card will admit any child under 14 years of age to FAIR GROUNDS on CHILDREN'S DAY, TUESDAY the 27th.

W. B. SCOTT, Pres. E. R. MOORE, Sec.

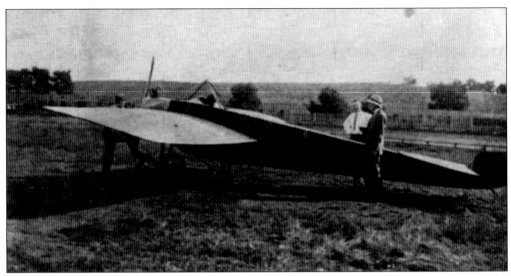

Max Lillie came to the fair in 1911 with the first airplane known to have flown in Iowa. The next year the fair had a Frenchman with a monoplane. In 1913, it was decided to try parachuting a man from the plane, and Lillie tried the jump with Edgar F. "Mickey" McGurrin. The jumps on the next two days were believed to be the first parachute jumps from an airplane. (Courtesy of the Anamosa Library.)

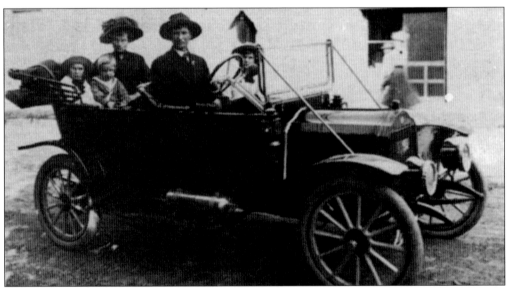

Another first came in 1914, when the Anamosa Fair came up with the idea to give away an automobile. The Fair Association sent a committee to Detroit with the idea and the manufacturers were so interested from the advertising standpoint that they practically donated the car. The winners were George and Laura Loehr. (Courtesy of the Anamosa Library.)

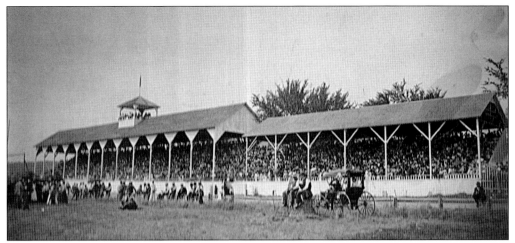

In 1895, a large amphitheater was built to hold 10,000 persons. Horse stables were moved to the south side of the fairgrounds, and trees were planted to make a shady park. The Fair Association boasted of its modern buildings. In September 1902, it was estimated that 15,000 people were in attendance at the Anamosa Fair and the amphitheater was inadequate to hold them. Plans were made to expand seating for the following year, but they were never followed through. However, the amphitheater was to meet a grisly end when it was destroyed by fire.

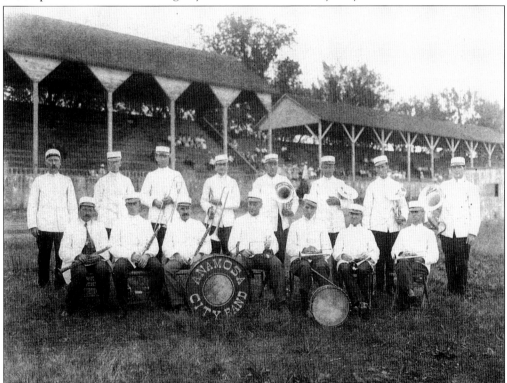

Local entertainers often performed at the fair. Bands from the surrounding communities showed their talent. The fairgrounds were also often used at times other than the fair for concerts and other entertainment. The schools often held sporting events there, such as the Anamosa-Monticello games.

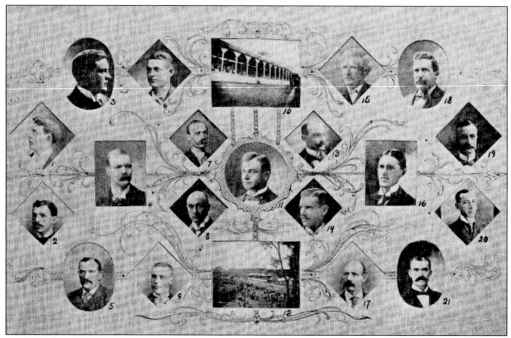

In this photograph, the members of the newly formed Anamosa Fair Association, founded in 1895, are shown. They include (1) T.W. Foley, (2) W.B. Scott, (3) chief of police Wm. D. Sheean, (4) T.E. Waters, (5) J.R. Washington, (6) Wm. McGuire, and (7) S.T. McLaughlin. (Courtesy of Picturesque Anamosa, compiled and published by W. Leon Hall, Cedar Rapids, Iowa, c. 1900.)

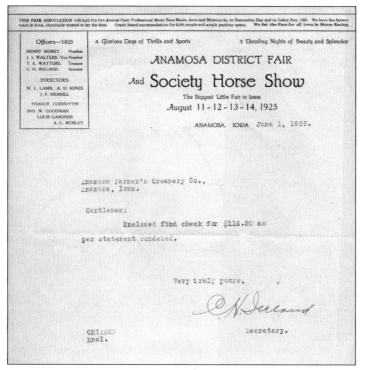

As this 1925 invoice to the Anamosa Creamery shows, the association was quite proud of its fair. It reported that "proof of the popularity and renown of the Anamosa Fair is exemplified in the distance some of the concessionaires have come to set up here. Cars bearing Florida, California, Missouri, Texas, Kansas, Oklahoma, and Colorado license plates may be seen on the grounds. All space for concessions was sold out long before any outfits arrived on the scene."

One of the ways the Anamosa Fair stayed financially stable was through the help of its stock holder support. Most years the fair was able to break even, if not gain some profit, until the very end when financial stress caused the association to declare bankruptcy and dissolve.

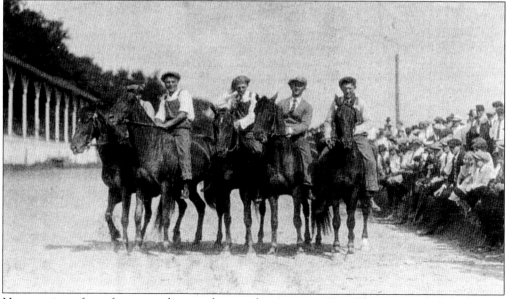

Horse racing of any form was always a draw at the Anamosa Fair. These young lads look ready to take to the track in this undated photograph. The boy in the center is even turning his hat to keep it from flying off.

With racing premiums being awarded as far back as 1865, horse racing was an institution at the Anamosa Fair. The first recorded racing purse was in 1865, won by Buckskin, a Dubuque horse. The 1866 fair was held October 3–5. A trotting race resulted in one horse so out-distancing the others that it won both the first and second purses, in accordance with track rules, but the second-place money was given back to be used the next day. Each year the popularity and size of the purses grew. One gentleman expressed his displeasure, saying "This horse racing has a bad influence by offering an inducement to the young men of our county to raise and train fast horses. Such slim neck, splinter shank things are not what farmers want." Editor Edmund Booth took exception to a subsequent regulation against wagering on horse racing and replied, "We too believe gambling is evil but still think it should be allowed for the enjoyment of people."

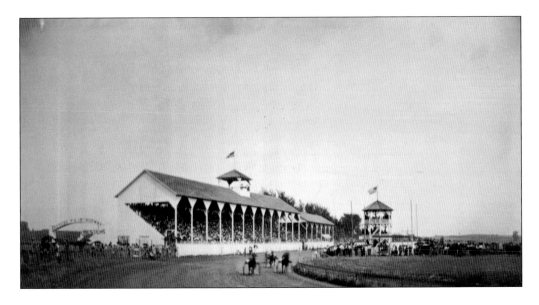

Eight

SCHOOLS

With a history dating back over 150 years, the Anamosa Community School District has continued to grow, offering excellence in education. The first school for some students was a log cabin a mile southwest of Fairview. Other students found schooling in their own homes or the homes of others. Churches often played a role in education and supplied classes or rooms for teachers and students. Early settlers constructed rural schools in buildings located near their homes. The rural schools were given quaint names such as Antioch, Black Oak, Hoosier Ben, and Frog Hollow.

One of the first indications of formal schooling was a notice in the *Anamosa Journal* published in 1856 that a Mr. O'Burke would commence a 12-week school at the cost of $3 per student for the term. In December 1858, an advertisement announced a free school conducted by J.R. Stillman at the United Brethren church. Another school was offered at Mr. Crockwell's residence by Emma Lang. In 1859, Hazel Knoll School offered formal schooling to young ladies.

During this time, the Anamosa Community School District was being formed. Counties were ordered by the state of Iowa to establish school districts. The public notices of school district requirements were published from December 1856 for one year. No action was taken until December 24, 1858, when the Iowa Board of Education passed Act 11, outlining the exact terms for the establishment of school districts.

In February 1959, there were four public schools: a brick schoolhouse at the foot of Strawberry Hill, Mr. Crockwell's residence, Brown's Building, and one in Belknap's neighborhood. There was also the private Hazel Knoll School. The total number of students was about 200. The first elected school officials were president William T. Shaw, vice president J.S. Dimmitt, secretary J.J. Dickinson, treasurer Israel Fisher, and directors Roswell Crane, R.S. Hudley, and David Graham.

From these humble beginnings, the Anamosa Community School District now serves a 134-square-mile area in Jones County and eastern Linn County, with an enrollment of approximately 1,370 students and 115 teachers.

As the Anamosa public schools were developing in 1859, the Hazel Knoll Family Boarding School, shown in this early 1900s photograph, was opened on April 18, 1859. It was started by the Isbell family, the Rev. and Mrs. Bishop Isbell and their daughters Eliza, Adelaide, and Emily. The school was located just a mile north of Anamosa, offering young ladies instruction in music on the piano, French, oil color painting, and other lessons of refinement. The entire 11-week term cost $38.50, including room and board. Families could also choose to have their daughters attend as day scholars, with classes individually priced. As a result of Eliza's death and Mrs. Isbell's ill health, the school closed in 1872. However, the Isbells remained active in education through Adelaide, the well-educated second daughter. She married Col. Charles F. Springer, a Civil War veteran, in 1866. Colonel Springer died on November 11, 1870, and Adelaide returned to Iowa in the summer of 1872; that fall, she became the principal of the Jones County Academy. The academy, located on the second floor of the I.O.O.F. building in Anamosa, was founded in 1870 and continued for 17 years, according to dates on an honor roll kept by Adelaide Springer.

Hazel Knoll Family Boarding School.

THE next and last Term, for the passing Academic year, of the Hazel Knoll Family Boarding School, will open on *Monday, 18th of April*, and will last eleven weeks.

Tuition in English Branches, Drawing, Painting in Water Colors, Drawing in Indian Ink, and Embroidery, with Board, Fuel and Washing for the Term, $38 50
Music on Piano, ... 10 00
French, .. 2 50
Oil Colors Painting, 5 00

A few day scholars will be received if desired.

Tuition in English, $5 00
Pencil Drawing, or in India Ink, 2 50
Water Colors Painting, 2 50
French, .. 5 00
Oil Colors Painting, 10 00
Music on Piano, with use of instrument, 10 00

BISHOP ISBELL.

Hazell Knoll, March 16th, 1859. 31w4

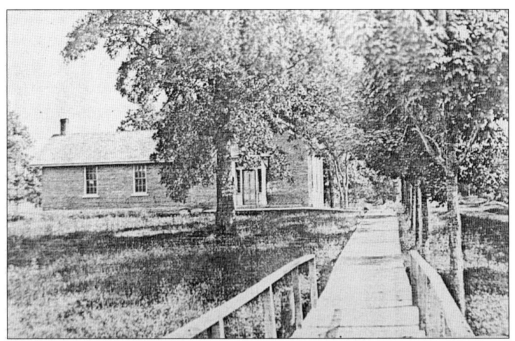

The Strawberry Hill School started in August 1857 when the *Anamosa Eureka* reported that W.T. Shaw, proprietor, intended on "putting up a good school-house this season, so that families that locate there will have the benefit of a good school, which is very desirable to parents, who feel a great interest in the education of their children." In April 1872, Strawberry Hill decided to remain independent of the Anamosa Schools and remained so until 1901. The school was located on the block west of First and Dubuque Streets where Wapsi Ana Park and the swimming pool are now located.

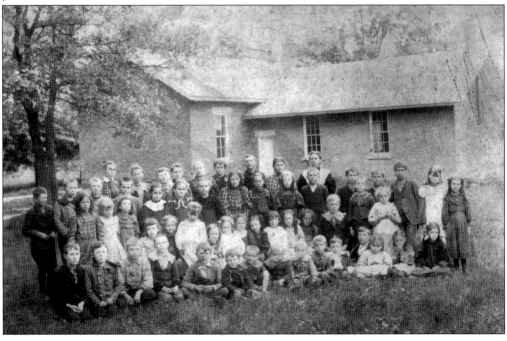

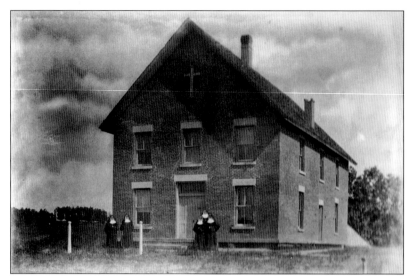

The Catholic school located on the hill on the north side of Anamosa was also an option for students in the 1890s. In June 1892, the two-story schoolhouse was struck by lightning and the upper story was severely damaged.

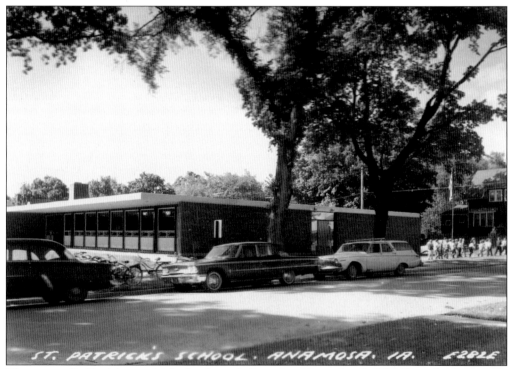

The present St. Patrick parochial school was dedicated on November 8, 1959. The school was built by Pastor J.A. McMahon, who established a grade school in 1944. The old school was a private home converted into school rooms for 65 students. In the fall of 1945, the school had eight grades with six sisters and a full-time music teacher. This building was moved to North Locust Street and was used as a family home after the current St. Patrick school was complete. It remains a school today, serving kindergarten through sixth grade.

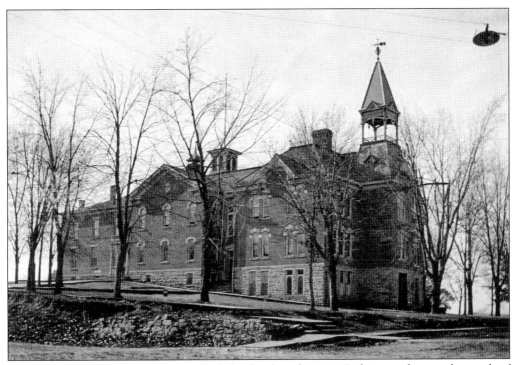

The long triple-decker look of the Graded School in these 1897 photographs was the result of the original school building receiving two additions. The site for the public school building, two and a half acres on the northeast corner of Section 10, in Fairview Township, was purchased in the spring of 1861 from Burton Peet. In April 1861, Alonzo Spaulding's construction bid of $4,475 was accepted. The Graded School was completed during the winter of 1862–1863, and the final cost was almost $8,000. It is the center section in these images. The addition to the back of the school was added in 1871. In 1885, an addition was built onto the front, which was to be the high school. E.C. Holt had the contract. There was some strife at the time as to whether a separate school should be built on the north side of town or as an addition to the Graded School. The addition won, as shown here. The top photograph shows the east side of the Graded School; the west side of the school is seen below.

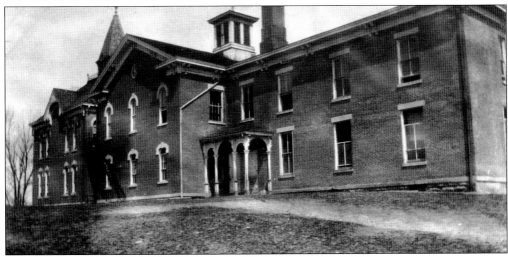

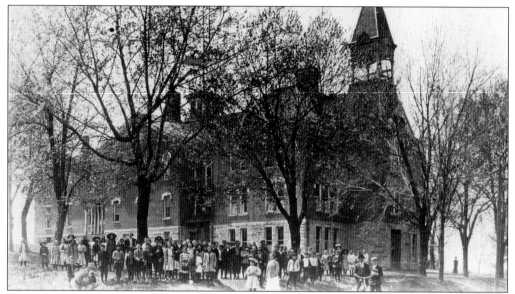

Prominent in any photograph of the Graded School is the bell tower high atop the north end of the school. The bell is one of the treasures of the Anamosa School District. The United Brethren church rented space to the school district in 1859.

The church earned a niche in history in 1953, when it brought the first bell into the county by oxen. The church subsequently closed and the bell was purchased by the Anamosa School District to be hung in the belfry of the Graded School.

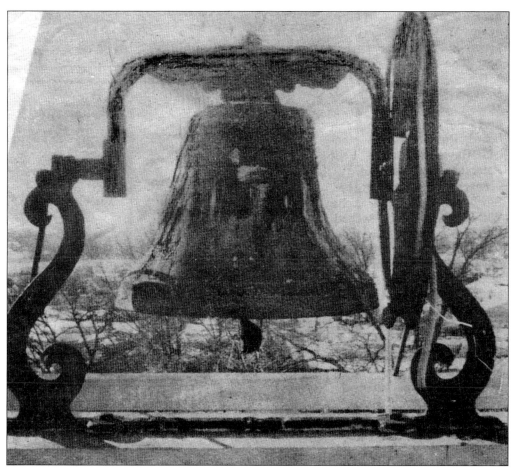

The bell, long unused, was removed to the high school in 1976 as the centerpiece of the bicentennial observances. It is still on display in the foyer of the high school, mounted in a replica of the original belfry. At one time, there was a tradition of ringing the bell following the close of commencement exercises each spring. A bronze plaque on the bell has a verse from a poem written by Harriet Cunningham in 1933: "Peal on, old Bell! Your work is not complete / Until our dull ears heed your message. / And our slow spirits catch your challenge. / And we rise up to give this needful time / Deeds worthy of our great inheritance."

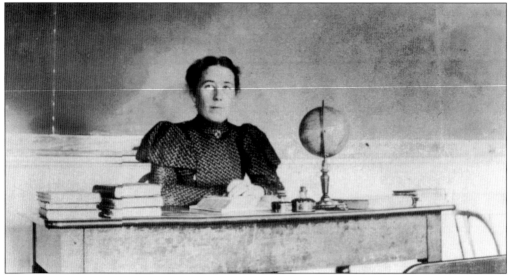

Sitting primly at her desk, as do the students, is Mrs. Doughtery's classroom in these c. 1897 photographs. The teachers were considered highly educated, and the interior of the Graded School quite modern, according to the *Eureka*, which had this to say when it was finished: "The first floor, divided into a spacious entrance hall, closets, wide stairways and two school rooms, each being 42 by 19 feet. Ascending to the second story we find a light, large and airy room appropriately fitted for a school room, 40 by 42 feet, also closets and a recitation room, this last 10 by 17 feet. In the upper rooms are Prof. Hammond and Miss Mary Ann George as teachers. In the two lower rooms are Misses Godwin and Crane. The exterior of the building is of the best finish. Every room is well lighted and, crowning all, is an observatory, 12 by 18 feet and 8 feet high, with 12 windows. This observatory is reached by a flight of stairs from the entrance hall of the second story. The whole affair is highly creditable to the contractor and architect, Alonzo Spaulding, and the chief mason, E.O. Holt, and the workmen under them."

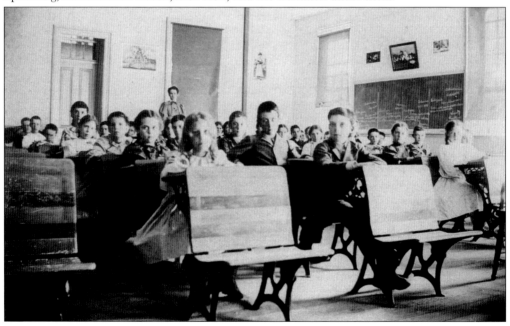

There were 13 teachers employed in the Graded School according to *Picturesque Anamosa*, including Frances Smith, Gladys Sigwoth, Margaret Dougherty, Charlotte Page, Etta Langan, Lillian Joseph, Prof. A. Palmer, Maude Humphrey, Nellie Gavin, Kate Hines, Stella Beam, Bessie Ewing, and W.R. Gregg.

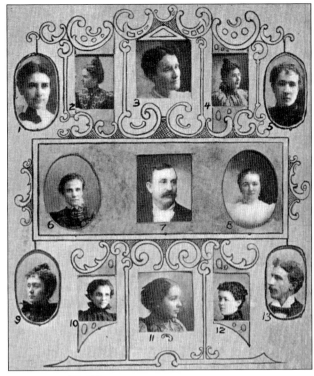

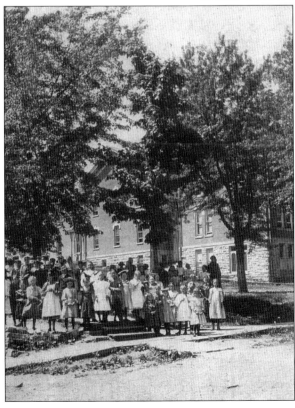

In 1910, the grammar school had an enrollment of 418, while the high school had 95 students.

In the 1909 Anamosa High School yearbook, *Anamoso*, special attention was given to the assembly room, which had been made more "homelike and attractive." Harriet Cunningham had presented a framed photogravure of Augustus Saint-Gaudens's *Abraham Lincoln: The Man*, the proceeds of a student exhibit had added a landscape painting, the class of 1909 presented Archibald MacNeal Willard's *The Spirit of '76*, the class of 1910 presented Sir Lawrence Alma-Tadema's *A Reading from Homer*, and the class of 1907 left a tastefully framed copy of George Frederick Watts's *Sir Galahad*. There was also a large steel engraving of *The Signing of the Magna Charta* as a bequest from the late Mr. E.C. Holt that held a place of honor at the front of the room.

A much-loved and appreciated teacher, Miss Gordan, donated the statue *Victory* that was quite prominent in the left front of the assembly room.

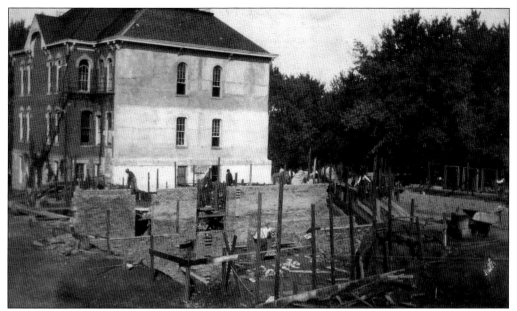

The plans for the new building were published in the February 6, 1913, edition of the *Anamosa Eureka* and voters approved keeping the 1885 portion of the public school to be used for the lower grades while the new building would be used as the high school.

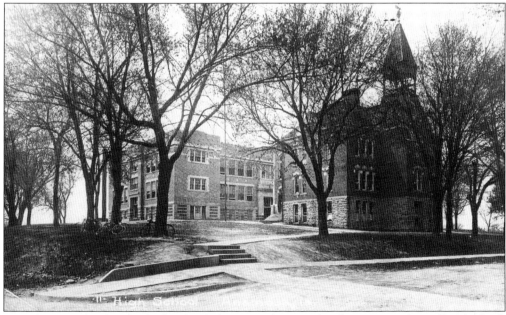

To make room for the new high school, the original 1861 schoolhouse was taken off of the back of the public school. It is said that some of the bricks were cleaned and used in the basement of the new building.

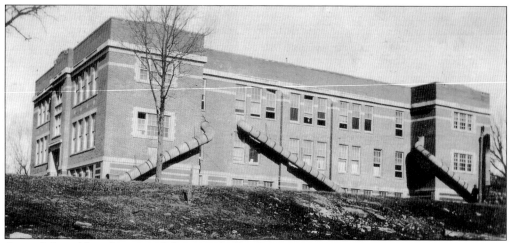

One of the oddest features of the 1913 high school was the long tubular fire escapes. These remained until the late 1960s and were a beloved place for the students to play.

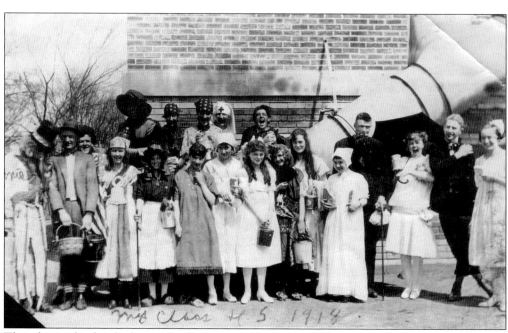

This class, ridiculously dressed for freshman initiation in 1918, poses in front of one of the fire escapes, showing the size of the long tubes.

This football player took time out to adjust his footwear in front of one of the fire escapes at the public school.

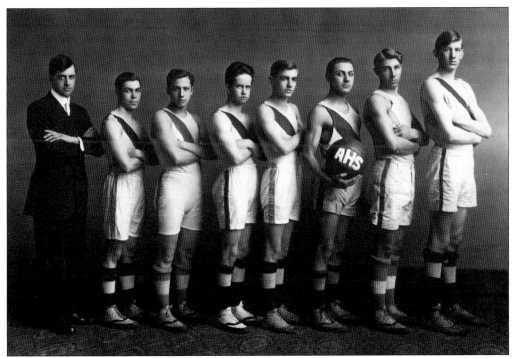

This 1920s basketball team shows the pride in sports that has always been a large part of the history of Anamosa. In 1921, the Anamosa High School basketball team made history by winning the Iowa State Class B championship but lost to Davenport for the state title.

Amid the troubled economic times of the 1930s, a proposal for the construction of an addition to the school was issued and approved. In 1935, the 1913 building was remodeled and an addition of $70,000 included classrooms, an auditorium, and a gymnasium. The new structure was placed on the southwest side of the 1913 building and included five classrooms.

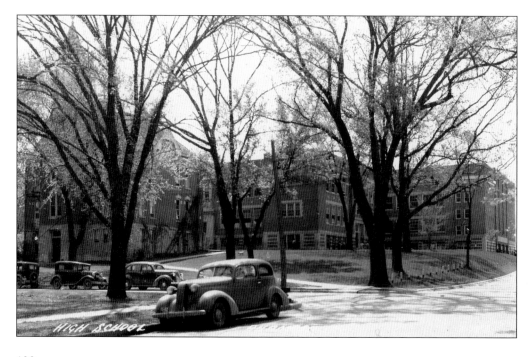

Principal Nichols puts the cowbell in the display case in 1969. In 1937, the Anamosa Rotary Club, in a effort to promote greater fellowship between the athletic teams of Anamosa and Monticello, secured a six-inch cowbell painted blue on one side with the letter A in white and red on the other side with a black M. The Anamosa Raiders retained possession of the cowbell after the first game by defeating the Monticello Panthers 20-0. The cowbell has since been passed between the two rivals each year at the classic cowbell football game.

Armistice Day Classic Ends
With 0-0 Deadlock

Players, Fans Freeze
In Howling Blizzard

onti Panthers Halt
Raider Consecutive
Victory String

By Charles Christenson

oach Wally Schwank's Blue
iders and Coach Emil Klumpar's
nticello eleven played to a
reless tie on the fairgrounds
Monticello Armistice day.

With the temperature at 19
egrees and an icy wind send-
ng snow flying across the
gridiron, the 2,000 fans who
urned out to witness the bat-
le between the two unbeaten
elevens went home, a disap-
ointed and very cold bunch of
ooters.

The tie ended Anamosa's con-
cutive victory streak of 27
aight wins, but they still have
t been defeated. The Raiders' of-
sive machine seemed to lack
usual smoothness and the
ong wind made punting almost
impossibility. Everything seem-
go wrong for Anamosa, altho
nticello gained only 45 yards

BRRR! A MONTI BLIZZARDKRIEG!

One of the most memorable games of the rivalry occurred on November 11, 1940. With temperatures at 19 degrees and an icy wind sending snow flying across the gridiron, more than 2,000 fans went home disappointed by a 0-0 deadlock. Up to that point, the Blue Raiders had a 27-game winning streak.

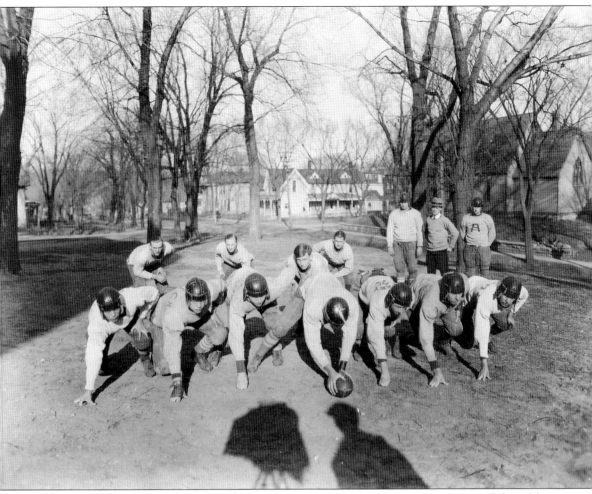

The Anamosa Raiders were a football powerhouse from 1937 to 1942, as they went undefeated for five years with a 47-game winning streak. Coached by Wally Schwank, Anamosa outscored its opponents 313-6. Four lettermen signing up for military service in 1943 marked the end of this unequaled era. During the 1945–1946 school year, the under-20 draftees were welcomed back to complete their high school education.

Anamosa School Pupils Build Model War Planes

Industrial arts students, under the supervision of Harold H. Hof, are busy daily doing their part for defense by shaping parts for model planes. These models, built to a scale of solid wood, are to be used by the army and navy in training pilots and gunners.

Department has already received plans for 20 types of planes and several have been completed. In the training laboratory, the models are given recognition and gunnery tests by silhouetting them on a white background. A plane that does not conform to specifications is useless.

Several fine models have been made by the classes in first year woodwork. Carl Underwood has completed a model of a "British Spitfire;" Dick Stoddard the "Bell Aerocobi," a plane built in America that is being used on the Russian front; Ernie Lowe, a German bomber, Heinkel H. E. III; Rex Meeks, a four-motored Navy patrol bomber; Jim Sinkey a Northrop Army attack plane, and Laverne Fulwider a Douglas torpedo bomber.

Certificate of awards are to be issued and each craftsman will be ranked according to the number of models completed. It is hoped that several of the completed models may be exhibited before sent to a training base for use by the

4/16/42 Journal

Supporting the war effort in 1942, the Industrial Arts students in Harold H. Hof's class built model airplanes that would be used in military training. More than 20 model types were made, with students receiving awards and rankings for craftsmanship.

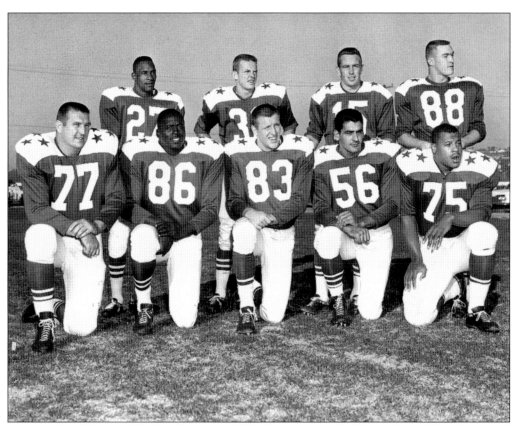

Don Norton is shown as No. 88 on the National Football League All-Star team and in his trading card for the Chargers. Norton attended Anamosa schools, graduating in 1956. He was crowned Homecoming King his senior year. He went to the University of Iowa, playing in the Rose Bowl twice. Norton played seven seasons for the Los Angeles/San Diego Chargers, making the AFL All-Star team two times. (Courtesy of Scott Werling.)

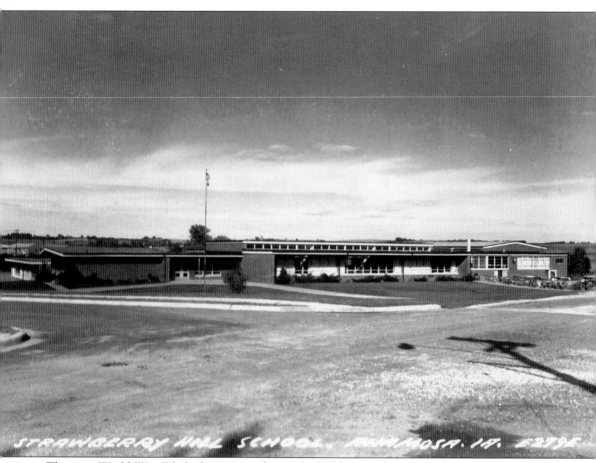

STRAWBERRY HILL SCHOOL, ANAMOSA, IA.

The post–World War II baby boom, together with the closing of many rural schools, overtaxed Anamosa's elementary classroom capacity. On May 14, 1954, approval was granted for the construction of an elementary school. The new Strawberry Hill Elementary School was occupied in the fall of 1956.

School district reorganization occurred in the late 1950s through the early 1960s. The Anamosa Community School District was officially established on July 1, 1962. The reorganization brought together the Anamosa Independent District, part of the Viola Consolidated District, and all or part of the Antioch, Black Oak, Brady, Cass, Fairview, Hoosier Bend, Midland, Waggoner, and Wayne rural school districts. When the reorganization was complete on July 1, 1963, it made rural one-room schoolhouses a thing of the past. The new district covered 134 square miles and had 76 staff members, with a student enrollment of 1,578.

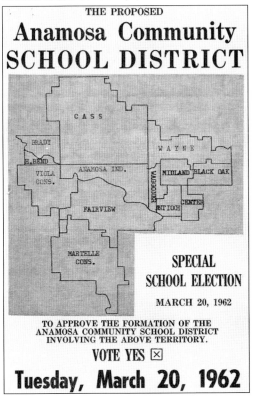

THE PROPOSED

Anamosa Community
SCHOOL DISTRICT

SPECIAL SCHOOL ELECTION
OCTOBER 24, 1961
TO APPROVE THE FORMATION OF THE ANAMOSA COMMUNITY SCHOOL DISTRICT INVOLVING THE ABOVE TERRITORY.

VOTE YES ☒

Tuesday, October 24, 1961

THE PROPOSED

Anamosa Community
SCHOOL DISTRICT

SPECIAL SCHOOL ELECTION

MARCH 20, 1962

TO APPROVE THE FORMATION OF THE ANAMOSA COMMUNITY SCHOOL DISTRICT INVOLVING THE ABOVE TERRITORY.

VOTE YES ☒

Tuesday, March 20, 1962

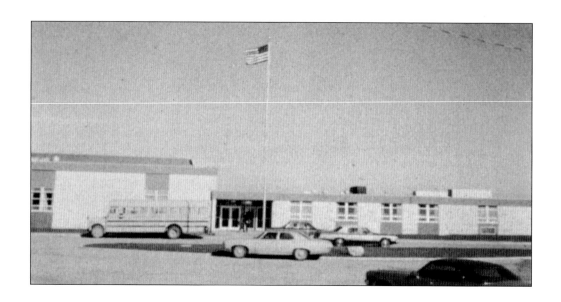

In 1964, a recommendation was made to build a new high school. In May 1966, the issue was approved. The new high school was complete in time for the 1968–1969 school year. It was considered the most modern of schools for its time, boasting all electric heat, offices for the teachers, and room for 750 students.

The West Elementary School building was demolished in the summer of 1982 after serving students for almost 100 years. The old buildings are commemorated by a brick marker built on the site by George Watters. The 1885 flagstone from the bell tower, bricks, and window stones used in the sign are from the original buildings. A bronze plate states, "This structure marks the site of the first high school in Anamosa." The 1914 building was renamed the West Middle School. Strawberry Hill, Martelle, and Viola continued as elementary schools until 1987.

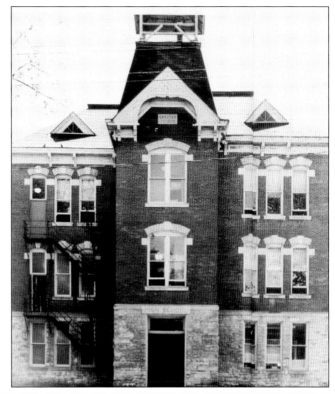

In November 1975, the school district purchased 5.48 acres of land next to the football field. The land became a track-and-field area as well and was also developed for a softball and baseball field. The need for a new track was most keenly felt by coach Ken Fearing, as his track team brought home a Class A state track championship.

Marshall Yanda attended Anamosa schools his entire life, graduating in 2003. He was a letterman in football, basketball, and track and field. Marshall played two seasons with North Iowa Area Community College in Mason City. He was a two-year starter who played both offensive tackle and guard. Marshall then transferred to the University of Iowa and was named the 18th best tackle in the nation in 2006. Currently Marshall is a starting offensive lineman for the Baltimore Ravens in the National Football League. He has been named to the NFL Pro Bowl three times. The Ravens were the Super Bowl champions of 2013. (Courtesy of Daryl Schepanski.)

Marshal Yanda

At the beginning of the 2012–2013 school year, the Anamosa School District opened a brand new middle school facility built expressly for the fifth through eighth grades. Costing more than $2 million, the facility was built without an elected bond on the taxpayers. It is located on Old Dubuque Road on the northeast side of Anamosa within walking distance of the high school and Strawberry Hill Elementary. (Courtesy of the *Anamosa Journal-Eureka*.)

Nine

PEOPLE, PLACES, AND THINGS

There are many men and women who kept Anamosa in business through the years. However, a select few braved the wilderness and were the first. Photographs of these original settlers who founded Buffalo Forks are unavailable, but their names must be noted in history.

Gideon H. Ford and his wife, Hannah, were two of the first. Ford moved the house that he and Edmund Booth had built down to Military Road to what is now the intersection of South Main and Mill Streets. The Fords used this building as an inn. This is the site where the girl named Anamosa left her legacy and her name for a new town.

Harry Mahan and John Crockwell kept the first store, which was a small room in a residence on the corner of Main and Iowa Streets. Crockwell was a young man often left in charge while his uncle went to Dubuque for more goods.

Calvin C. Reed established a mill on the Wapsipinicon, approximately where the iron pedestrian bridge is now.

In 1847, $800 was raised to build a courthouse on the hill of East Hickory Street. This was also the location of one of the first schoolhouses.

The second mercantile firm was that of Skinner and Clark in 1847. Gillett and Osborne became dealers in general merchandise about the same time. November 1847 saw the first post office open, and a man by the name of Rockwell was listed as the first lawyer. Dr. Clark Joslin was the first physician. His son, J.M.D. Joslin, was also a doctor. Being enterprising men, Dr. Joslin and John Crockwell established the first drugstore.

The first tailor was William Sterling, in 1848. He was afterward recorder and treasurer for the county.

About 1848 or 1849, J.H. Fisher opened a store at the mill on the Buffalo and, after a time, moved his stock to Anamosa and continued the business.

These enterprising souls, and others after them, came to Buffalo Forks with little more than their dreams and set about putting Anamosa on the map. They were instrumental in making it the county seat, getting the state penitentiary, and having places to play.

No story of Anamosa can be written without mention of Edmund Booth and his wife, Mary Ann. Edmund followed Mary Ann Walworth to the Iowa wilderness and theirs was the first marriage recorded in the county. The Booth couple were both deaf, having lost their hearing on account of childhood diseases. Given his total deafness since the age of eight, Edmund's powers of speech as an adult were remarkable.

Mary Ann communicated only through sign language and writing. Edmund went to the California goldfields in 1849, leaving Mary Ann and two young children at home in Anamosa for five years. He sent gold back to Mary Ann. She invested in land, built a house, and took responsibilities that were beyond the experience of many women, even hearing women, of her day. She bought what became prime real estate in Anamosa, bounded by Main, Booth, First, and Fourth Streets. Part of this land was donated for the public library and the Booths also donated the first site of the Congregational church on Main Street. Shortly after Edmund returned from California, he bought the *Anamosa Eureka*, which he edited until his retirement in 1898.

Thomas Eyre Booth, son of Edmund Booth, is pictured here as he appeared in his later years. He was editor of the *Eureka* until 1911. Thomas was Edmund and Mary Ann's oldest child, born in 1841. He entered the newspaper business with his father and upon his father's retirement became owner and editor. He married Gertrude Delevan and they made Anamosa their lifelong home. Gertrude also became involved with the *Eureka* and gave many valuable suggestions and assistance to the editorial department. During his more than 50 years of influence while publishing the *Eureka*, T.E. Booth always printed what was considered a good newspaper with the best interests of the community at heart. No community event of good cause can be found during their lifetimes that did not involve the Booth family.

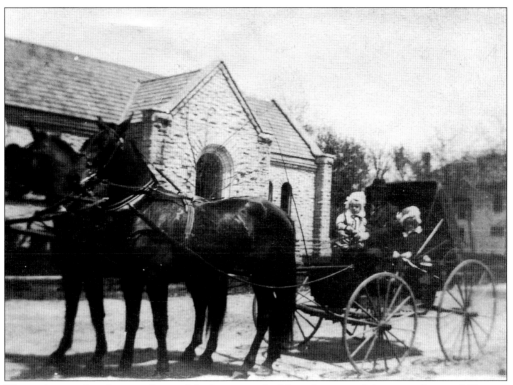

This unknown family sits in front of the limestone building that served Anamosa for over 100 years as the public library. In 1900, Walter S. Benton bequeathed $10,000 for books provided that the city would build a library. In 1904, the library opened, thanks to the Daughters of the American Revolution, who raised the money for the building, and the Booth family, who donated the land on the corner of First and Ford Streets. In 1983, the library was listed in the National Register of Historic Places. The limestone structure still serves as the police station.

Anamosa had outgrown the little limestone structure, so starting with the donation of land by Ernest and Lester Buresch and a $200,000 Vision Iowa CAT grant, the quest for a new library began. Ironically, Charlene George, a member of the DAR, spearheaded the worthy project. In December 2004, a grand opening was held for the new public library, located just down the street from the old one at the corner of Scott and First Streets.

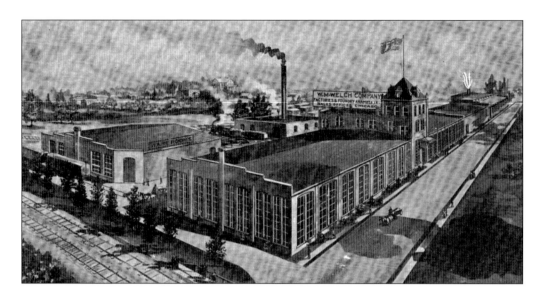

W.M. Welch of Chicago established the Welch Factory in Anamosa in 1902. This structure was home to the business of publishing, lithographing, and printing books, as well as manufacturing and selling all kinds of bank, office, and school supplies, including desks, tables, and other furniture. In 1905, it was reportedly doing $175,000 worth of business and was touted as the largest factory of its kind in the world. It employed over 100 seasonal workers. On December 21, 1905, Welch was ousted by the board of directors. Troubles plagued the company, and on June 7, 1913, it was sold at a sheriff's sale. The Anamosa directors reorganized under the name Metropolitan Supply Company, with George Schoonover as president, vice president Louis Gardiner, and manager Clark A. Beems. Even though many of the old books, records, and forms preserved in Jones County contain the names of W.M. Welch Co. and the Metropolitan Supply Company, the business was eventually wooed to Cedar Rapids. The land was later donated to the city for the new library.

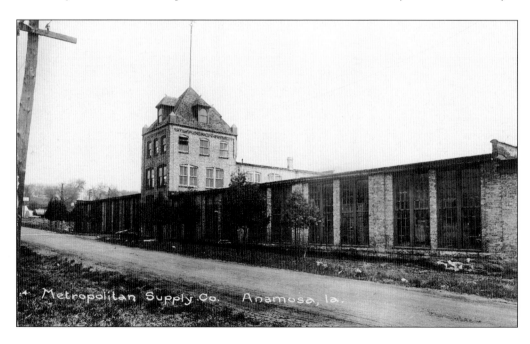

Col. William Tuckerman Shaw, born September 22, 1822, was a native of Maine. He was a teacher until the Mexican War broke out in 1846, when he enlisted as private in the 2nd Kentucky Volunteers. In 1848, Shaw went to Arkansas and then found his way to the California mines. He came to Anamosa the first time in 1851, then went back to California in 1855, returning in 1859 to speculate in real estate. His name was connected with many of the enterprises of Anamosa afterward. He was the first mayor in 1856, was on the school board for many years, in the legislature in 1875–1876, and built the old Congregational and Methodist churches, the Shaw Block, many other downtown buildings, the schoolhouse on Strawberry Hill, and a number of residences in various parts of town. Included among the latter was his own spacious, handsome home. Colonel Shaw was instrumental in the building of the railroads to Anamosa, and for more than 35 years he was the senior member of the Shaw & Schoonover Bank.

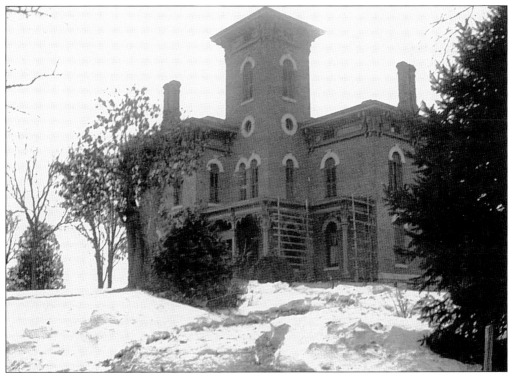

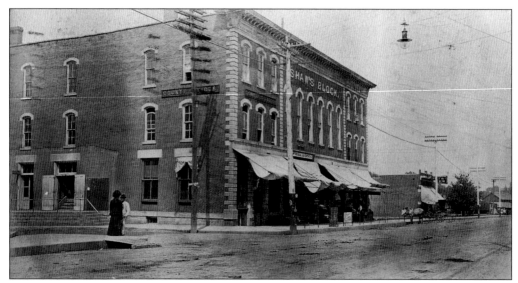

The Shaw Block was the first permanent location of the Jones County offices. Designated the county seat on June 11, 1847, while still called Lexington, a small wooden frame structure was built in the original part of town on Hickory Street. In 1864, the county records were moved uptown, into the second story of a newly constructed brick building on the west side of Ford Street. The county offices then moved into the Shaw Block in 1871.

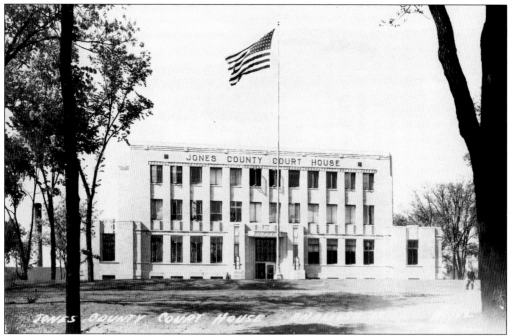

The present courthouse stands on the 400 block of West Main Street and was built in 1936, starting with a grant of $74,250 received from the Public Works Administration in June 1935. An election by Jones County voters in September approved the construction. Work on the new structure progressed and the planned opening date was set for September 10, 1937. More than 6,000 people attended the event and 250 musicians from the school and municipal bands entertained the crowd.

One of the beautiful Main Street features that the city of Anamosa sacrificed for the new courthouse was its city park. Many events and ceremonies were held at the park, including one on August 6, 1885, mourning the death of Gen. Ulysses S. Grant. The memorial was presided over by Col. W.T. Shaw. Another favorite pastime in the park was the performances by the state reformatory bands. Given a short period of release from their labors, the inmates were brought in chains one block south to the park, given freedom to perform, then marched back to their confinement.

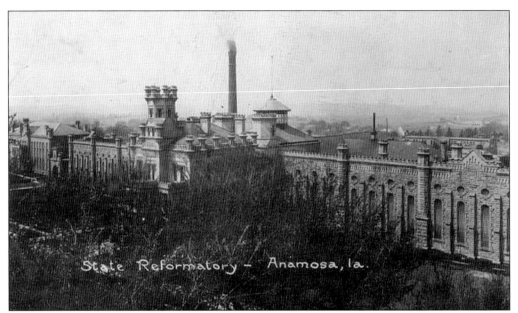

The Anamosa State Penitentiary dates back almost 140 years. First a penitentiary, it was, like most early institutions, built by the inmates who were sentenced there in the 1880s. On April 23, 1872, the 14th general assembly appointed William Ure, Foster L. Downing, and Martin Heisey as a board of commissioners to locate and provide for the erection of an additional penitentiary. The board met on June 4, 1872, at Anamosa and selected a site within the corporate limits of the city. Designated a reformatory in 1907, the emphasis was on younger offenders. Women prisoners were housed at the "Female Department" at Anamosa until the Women's Reformatory was established in 1918. Fifteen acres were donated by the citizens of Anamosa to the State of Iowa. Anamosa inmates still work the state farms. The first reception center opened at Anamosa in 1981, processing admissions to the Iowa prison system with little additional staffing, until the 1983 opening of the reception center at Oakdale. In 1997, the Iowa State Legislature, acknowledging the changing nature of Anamosa's prison population, officially renamed the prison the Anamosa State Penitentiary.

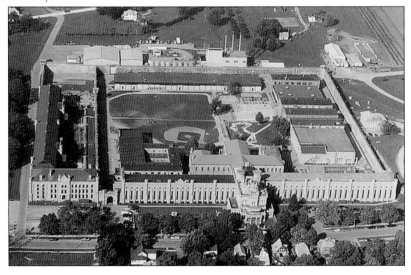

This 1890s photograph of the Riverside Cemetery, located on the southwest edge of town on the banks of the Wapsipinicon River, looks toward the east. The first person buried in Riverside Cemetery was a child of John Leonard. Leonard was working in Anamosa (then Lexington), and his family was with him. His child died, and as there was no regular burying ground, the child was buried on a hill overlooking the fork of the Wapsipinicon River and Buffalo Creek. All who died here in the years that followed were buried on the same hill, and finally, in 1854 or 1855, the ground, which was the property of G.H. Ford, was laid out into burial lots. The cemetery is the final resting place for many of Anamosa's notable citizens, including Grant Wood, the famous regionalist painter.

The Soldiers' Monument, located inside Riverside Cemetery, was financed through the efforts of the Women's Relief Corps. The planning of the monument had been talked about for more than 50 years prior to its dedication on May 30, 1911. In 1864, during the Civil War, the *Anamosa Eureka* proposed a monument for "our soldiers who fall in battle." It was intended to have the names inscribed on the memorial. Even though the subject was brought up many times, it wasn't until the Women's Relief Corps took matters into its hands in 1909 that the monument became a reality. The Union soldier was sculpted by A. Rozzis. The entire monument is Barre granite except for the inscription, which is Wisconsin mahogany granite. The monument was ordered on November 11, 1910, and placed April 22, 1911. Thirty-four surviving Civil War veterans took part in the dedication ceremony held on May 30, 1911.

Grant DeVolson Wood (February 13, 1891–February 12, 1942) was an American painter known for his paintings depicting the rural American Midwest, particularly *American Gothic*, an iconic image of the 20th century. Wood's father, Maryville Wood, married Hattie Weaver in 1856 and lived on a farm east of Anamosa. Prior to her marriage, she taught school in the little brick schoolhouse on Strawberry Hill. (Courtesy of Paint 'n' Palette Club.)

Grant Wood was born in this farmhouse just east of Anamosa, where he showed an interest in drawing. The only drawing materials he could get were the sheets of white cardboard enclosed in the wooden boxes of crackers that his father bought in Anamosa. His studio was underneath the oval dining room table, which was covered with a red checkered cloth. The house was destroyed by fire in 1974. (Courtesy of Paint 'n' Palette Club.)

Grant Wood enjoyed vivid sense impressions and observations of nature. An article in the *Anamosa Eureka* on April 15, 1901, reveals that "Master Grant Wood only ten years of age reports that he has found 55 varieties of birds in his neighborhood. His communication on this subject is very interesting and shows he is an observing thoughtful and wide-awake boy." (Courtesy of Paint 'n' Palette Club.)

Grant was never too far removed from his native area, often coming back to visit family and friends in the years that followed. In 1932, he established an independent art colony in Stone City, a quarry town three miles southwest of Anamosa. Artists lived in ice wagons, which they painted themselves. They were headquartered in the old stone Green mansion and there were public outdoor sales on weekends. After two summers, financial and other difficulties ended the colony. In 1938, as part of the Anamosa Centennial, Grant wrote a letter to Harriet Cunningham in which he stated, "Anamosa has always held a very warm place in my heart. . . . I am sure that every native of the county is, as I am, proud to have been born there, and cannot today go through Anamosa and Stone City country without having awakened memories and affections that extend back into earliest childhood."

DISCOVER THOUSANDS OF LOCAL HISTORY BOOKS
FEATURING MILLIONS OF VINTAGE IMAGES

Arcadia Publishing, the leading local history publisher in the United States, is committed to making history accessible and meaningful through publishing books that celebrate and preserve the heritage of America's people and places.

Find more books like this at
www.arcadiapublishing.com

Search for your hometown history, your old stomping grounds, and even your favorite sports team.

Consistent with our mission to preserve history on a local level, this book was printed in South Carolina on American-made paper and manufactured entirely in the United States. Products carrying the accredited Forest Stewardship Council (FSC) label are printed on 100 percent FSC-certified paper.

MADE IN THE USA